IMAGES
of America

BOTHELL

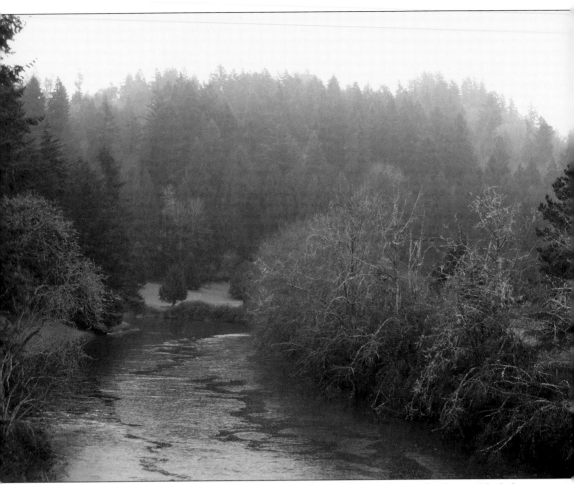

This photograph of the Squak Slough (Sammamish River) was taken at the former Blyth farm on February 21, 2017. It is not hard to imagine what it was like to row up this river on a rainy day in the late 1800s. Many of those who made the trip turned around and went back to civilization once they experienced the hardship of trying to settle among the dense forests surrounding the river. Norway Hill, now covered with second-growth evergreen trees, is prominently displayed in this photograph, and Wayne Golf Course, with its groomed meadow, is also visible. (Author's collection.)

ON THE COVER: The Cooperative Mercantile building remains in the same location as when it was first built in 1908. (Bothell Historical Museum.)

IMAGES
of America

BOTHELL

Margaret Turcott

ARCADIA
PUBLISHING

Published by Arcadia Publishing
Charleston, South Carolina

Printed in the United States of America

Library of Congress Control Number: 2016959819

For all general information, please contact Arcadia Publishing:
Telephone 843-853-2070
Fax 843-853-0044
E-mail sales@arcadiapublishing.com
For customer service and orders:
Toll-Free 1-888-313-2665

Visit us on the Internet at www.arcadiapublishing.com

CONTENTS

ACKNOWLEDGMENTS

This book would not have been possible without the Bothell Historical Museum and its extensive collection of photographs, newspapers, firsthand stories, and biographies written by early Bothell historians. Special thanks to Terri Malinowski for her advice and guidance, to Pat Pierce for all the field trips, and to Ed Alto for his masterful map work.

Many people helped by providing photographs, documents, and stories: Sue Kienast, Ron Green, Don Bagnall, Karin Bagnall Poage, Robert Beckstrom, Barbara Ramey, Pam Johnson, Lucile M. Brackett/Dunn, Brian Wescott, Ellen Carnwath, Bev Schmer, Ann Aagard, Dave Harkonen, David K. Black, the Northshore School District, the Greater Bothell Chamber of Commerce, and the City of Bothell. Thanks also go to 4Culture for its support of the Bothell Historical Museum.

Todd Lundberg and Gene Taylor from Cascadia College helped with the conceptualization, L.J. Mowrer from the Hibulb Cultural Center provided insight into the Native American presence in the area, and Joannie Moore introduced me to the Waterman research. Candace Stenseth and Judy Woo read chapters as they were being completed. Steve Turcott identified the old band instruments, and Jon Turcott helped pinpoint locations.

Thanks go to Caroline Anderson for being such a supportive title manager, and to Arcadia Press for giving me the opportunity to tell the story of Bothell.

Special thanks go to my husband, Jim Turcott, whose advice, assistance, and patience made it possible for this project to be completed.

Unless otherwise noted, all images appear courtesy of the Bothell Historical Museum.

INTRODUCTION

The geography of the Bothell area was formed when the last glacial period made it a true basin with no natural outlet to a water course. Swamps, peat bogs, rich agricultural soil, hardpan, and clay were left in the Sammamish Valley. The Sammamish River was first called Squak Slough because of its swampy nature, but it is actually a river connecting Lake Sammamish to Lake Washington. In 1916, Lake Washington was lowered, and the Sammamish River dropped 10 to 14 feet. Later, the river was dredged and straightened turning the meandering river into an even slower-moving waterway.

Fewer than 200 Indians lived alongside the Sammamish River in the 1870s; they were known as the Meanderer Dwellers by other Indians in the area and were said to be poor. Bothell pioneers remember that there were Indian camps in the woods around the settlement and that the newcomers had good relations with the Indians. Gerhard Ericksen's son Carlton talks of delivering groceries to a camp near Kenmore. At least two area women—Belle Bothell and Susan Woodin—were able to speak Chinook Jargon. In the 1880 territorial census, at least 100 Indians were noted as being found near Monroe, Washington; it is likely that they were picking hops for Gustav Jacobsen in Woodinville. According to Harriette Shelton Dover, hop farmers relied on Indians for harvesting that important crop.

Life in the new region was harsh. Trees lined the river, and it was almost impossible to walk through the dense forests—let alone build a home. Naturally, logging was the first occupation in the settlement, and loggers cut the trees leaving stumps of 10–20 feet, so many homesteaders were called stump farmers. Dynamite was one method used to eliminate stumps, and although the stories of flying roots and parts of trees are humorous, they also highlight the dangers of everyday life in the area.

Even as Bothell became settled, life was not easy. Disease took many lives. The Swedish Lutheran church wrote that it needed to fill in and relocate its outhouse, since it was the source of typhoid among congregants. The Seattle, Lake Shore & Eastern Railway came to Bothell in 1887 and was purchased by the Northern Pacific Railway in 1892. One Bothell family lost their two-year-old child when he was decapitated by the train. The first Methodist minister, Alfred Crumley, was killed while walking on the tracks in 1909.

Bothell grew slowly until after 1914, when a short piece of road was built that connected Bothell to Lake Forest Park and on to Seattle. That short road, along with the availability of Ford's Model T automobile for the masses, connected Seattle and Bothell. Charles Green sold a Winton touring automobile to the Ross family in Bothell and ended up driving the family across the United States in the first car to travel west over Snoqualmie Pass. Green started an automobile repair shop in Bothell and later owned a Ford dealership. He married Sarah Simonds, one of the first graduates of Bothell High School.

Bothell started as a logging community out of necessity. Eventually, farming, chicken ranches, and dairies took over as the main types of enterprise. Bothell then became a bedroom community of Seattle, since commuting to the city for work was possible with cars and buses. A "Technology Corridor," a University of Washington and Cascadia College campus, and growth in schools, churches, and businesses have all made modern Bothell a vibrant place to live and work.

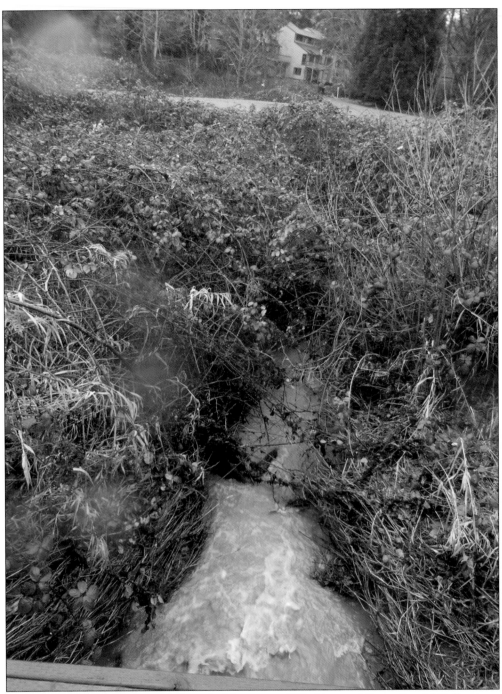

In a 1920 unpublished manuscript from the University of Washington Library Special Collections, T.T. Waterman identified Native American names of landmarks in the Puget Sound area. Some streams and creeks that feed into the Sammamish River are on his list. One stream with the translated name of "a lot of brush piled up" is said to enter the river from the south, just below the town of Bothell. This appears to be that stream, which is located on the back nine of Wayne Golf Course. (Author's collection.)

8

One

EARLY SETTLEMENTS

In 1870, George Wilson rowed up the Sammamish River and located a home site. He went back to Seattle to work for a while and was intending to return to the area he claimed. In the meantime, Columbus Greenleaf settled on the property that Wilson had selected. Since there was plenty of desirable land available, Wilson claimed new property north of Greenleaf's and developed a farm on the hills above the river. In 1876, George Brackett bought land east of Greenleaf's and began a logging operation.

By 1880, John Blyth and Mattias Bargquist had settled on the river west of the claims of Brackett, Greenleaf, and Wilson. This area at the west edge of the emerging settlement was called Blyth and then, when the Seattle, Lake Shore & Eastern Railway came, Wayne. In addition to Wilson, Greenleaf, Blyth, and Bargquist and their families, others began to settle in the region. The Beckstroms, Quartmans, and Ericksens settled just south of the Snohomish County line. The Andersons, Helen DeVoe, William Hannan, and Jacob Mohn all found property in Snohomish County. The Bothells, Keeners, and Campbells settled in the area where George Brackett's logging operation had been, and Alfred Pearson settled on the Norway Hill side of the river.

Logging was the primary occupation of the area's citizens. The dense forests surrounding the river needed to be cleared so that crops could be planted, homes could be built, and roads could be created. Will Verd, an aspiring writer and logger, called the forests around Bothell "green gold." By the mid-1880s, lumber and shingle mills provided a thriving economy. Retail stores, hotels, and other businesses defined a growing downtown area.

Gerhard Ericksen, owner of a general merchandise store, routinely crossed the river to pick up the town's mail in Woodinville. He often had to swim across the river with the mail held in his teeth when the boat he used was on the opposite shore. In 1889, David Bothell platted the town, a post office was established, and Ericksen suggested calling the town Bothell.

In 1902, Harry Tracy, a notorious killer, escaped from prison in Oregon and terrorized the state of Washington. He arrived at Wayne and killed two men before he escaped. This incident put the brand-new town of Bothell on the map.

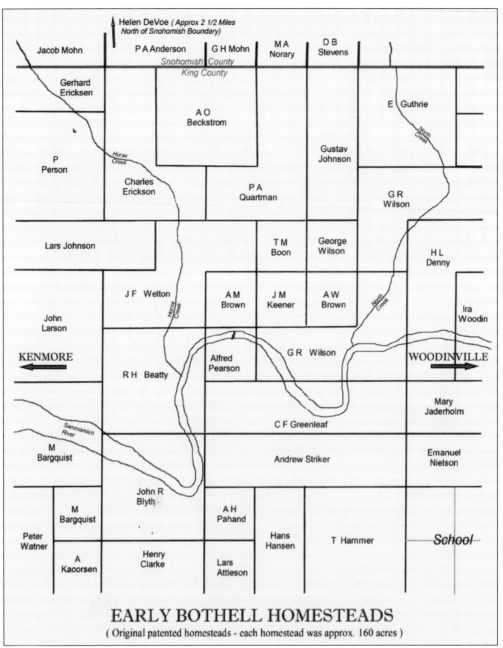

Helen DeVoe (Approx 2 1/2 Miles
North of Snohomish Boundary)

Jacob Mohn P A Anderson G H Mohn M A D B
 Norary Stevens

Snohomish County
King County

Gerhard
Ericksen
 E Guthrie
 A O
 Beckstrom
 Gustav
 Johnson
P
Person
 Horse
 Creek
 Charles P A G R
 Erickson Quartman Wilson

Lars Johnson T M George H L
 Boon Wilson Denny

 J F Welton A M J M A W
 Brown Keener Brown Ira
John Woodin
Larson

KENMORE G R Wilson **WOODINVILLE**
 Alfred
 R H Beatty Pearson

 Mary
 Jaderholm
 Sammamish
 River
 C F Greenleaf
M
Bargquist Emanuel
 Andrew Striker Nielson

 John R
 Blyth
 M A H
 Bargquist Pahand
Peter Hans
Watner Hansen T Hammer *School*
 A Henry
 Kaoorsen Clarke Lars
 Attleson

EARLY BOTHELL HOMESTEADS
(Original patented homesteads - each homestead was approx. 160 acres)

An unidentified Bothell/Woodinville pioneer drew a map based on his memory of who were homesteaders/property owners in 1886. The nearly unreadable map has been carefully reproduced by Ed Alto for this book. Some of the original homesteaders did not stay in the area long and sold their claims. Joseph Blyth purchased some of the land of R.H. Beatty and J.F. Welton. Following the river from west (Kenmore) to east (Woodinville) are the Bargquist, Blyth, Greenleaf, Pearson, and Wilson homesteads. Ira Woodin, who arrived in the area around this time, established the community of Woodinville.

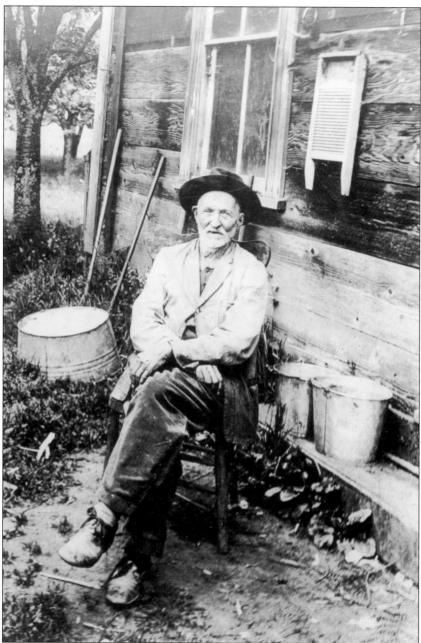

Columbus S. Greenleaf, a native of Maine, was the first white settler in the community. He cleared an area on the south side of the river. Later, when the Seattle, Lake Shore & Eastern Railway came to Bothell, Greenleaf moved his home across the river to avoid being so close to the trains. This photograph is thought to have been taken at his new cabin across the river from his original homestead. When the Bothell School District was created, Greenleaf was one of its first directors. He opened his home to the Norwegian Lutheran congregation for worship until its church building was completed. He was a charter member of both the Bothell Masonic Lodge and the Order of the Eastern Star. Greenleaf never married, but he was a welcome guest at and part of many Bothell family and community celebrations.

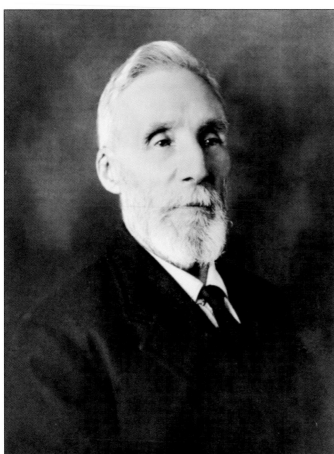

George Wilson, one of the first settlers in the area, was a man of mystery. Born as George Ridley Chislett in England, he joined the British navy and deserted, along with 100 others, when his ship was being repaired in San Francisco. Wilson made his way to Seattle and then up the Sammamish River to settle where the University of Washington Bothell is now located.

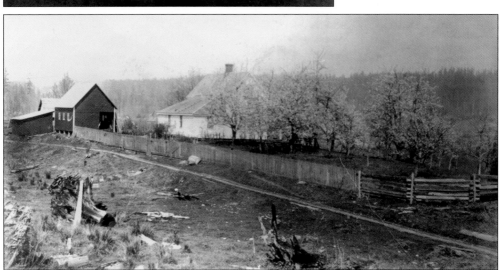

This is an early photograph of George Wilson's farm. Wilson was a civic-minded man who was active in community life. He donated the first organ to the Methodist church and, according to Gladys Worley, a member of the pioneer Hannan family, he welcomed the town's children into his yard to pick cherries from his cherry trees. When he died, his estate was worth over $250,000.

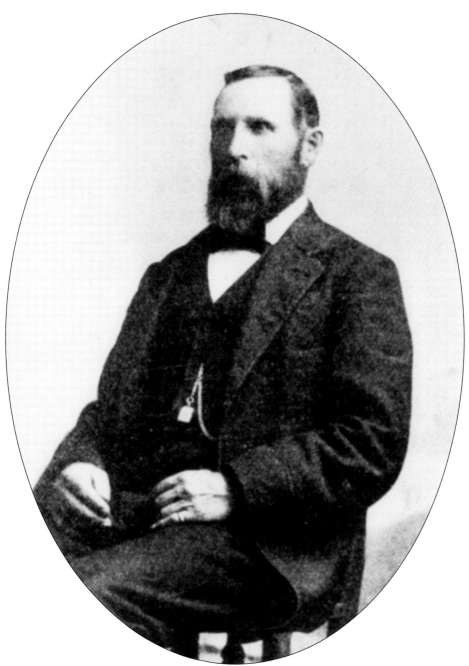

George Brackett was born into a family of woodsmen, grew up in Canada, and later moved to Maine to work in the forests. He arrived in the Seattle area in 1869 and paid $360 to Arthur Denny of Seattle to acquire 80 acres along the Sammamish River. Brackett then added 160 acres to his original purchase and began a logging operation in 1877 using oxen on the current site of Bothell. George Wilson gave Brackett the right to log and create roads on some of his property, adding to Brackett's enterprise. The area on the river just east of the present-day Park at Bothell Landing was where the logs were dumped. Once Brackett had cleared most of the timber in this area, he moved to Edmonds, Washington, where he spent the rest of his life.

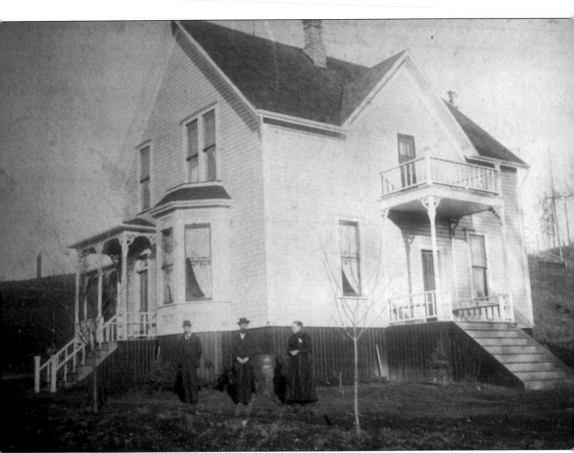

On March 11, 1885, John and Christina Blyth were married at John Blyth's home—the first wedding in the area. It was a festive celebration; the party lasted well into the night and featured an elegant supper that included oysters. Bill Johnson and John Bittinger played their fiddles for lively dancing. A partial guest list included the Woodins, the Bothells, the Keeners, the Ericksens, the Ericksons, the Quartmans, the Beckstroms, Columbus Greenleaf, and George Wilson. The bride spoke only Swedish, and the groom spoke only English. Pictured here outside John Blyth's home are Joseph Blyth (John's brother), John Blyth (center), and Christina Blyth (right).

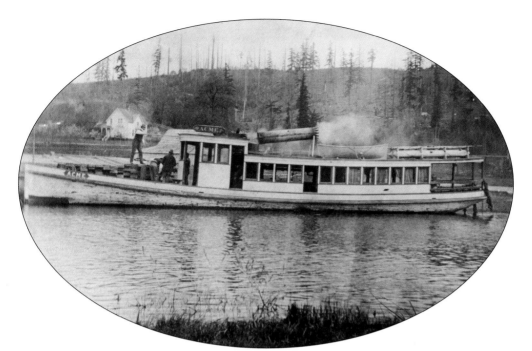

The Blyth family home is visible in this photograph of the steamer *Acme*. The area was called Blyth's Landing/Blyth's Curve because of the river's sharp turn at the property. After the railroad came in 1887, the first year it only went as far as Blyth's Landing, and the makeshift depot was named Wayne. No one knows why it was named Wayne, but the name is still used today.

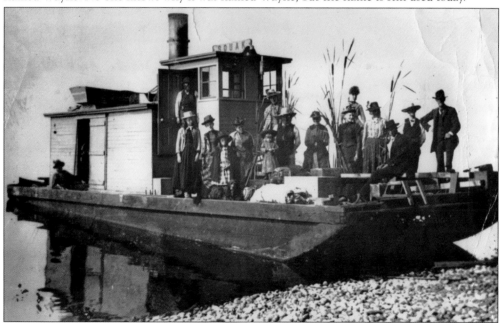

The *Squak* was one of the earliest boats to navigate the Sammamish River. This shallow-draft scow ran from 1884 until 1892. It was the first boat to regularly run between Seattle and Issaquah and most likely stopped at Blyth's Landing as well as the wharf in Bothell at the bottom of what was First Street.

This undated photograph shows the 65-foot steamer *City of Bothell* (formerly the *May Blossom*) approaching Blyth's Landing. The *City of Bothell* had a foldable smokestack, which is visible in this photograph. The smokestack could be lowered to travel under bridges, trestles, and other obstacles as necessary due to the fluctuation of the water level and trees and vegetation. The *City of Bothell* is approaching Blyth's Landing after just leaving the First Street wharf in town. The four people on the dock appear to be ready to board the boat, since they are in somewhat formal clothing. Before Lake Washington was lowered in 1917, the river was about 14 feet higher. Today, the Riverbend Condominiums dock is in approximately the same area as the dock in this photograph (but many feet lower).

Mattias Bargquist, a farmer from Swedish Finland, was an early settler on the south side of the river across from John and Christina Blyth. He married Annie Johnson from Stockholm, Sweden. This c. 1897 photograph shows Mattias, Annie, and their daughter Matilda "Tillie." They had one more child, Bertha, in 1899.

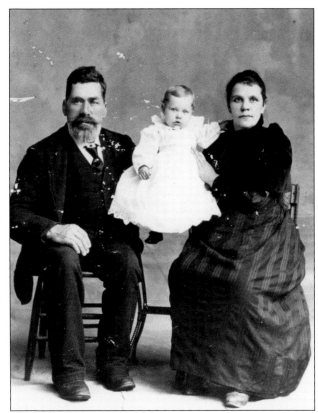

The Bargquist family's two-story home is finished with cedar shingles—a common practice, since Bothell was known for the quality of its shingles. The two women in the photograph are not identified, but the woman at left may be Annie Bargquist. It is possible these women are at the river's edge and are holding the line of a boat.

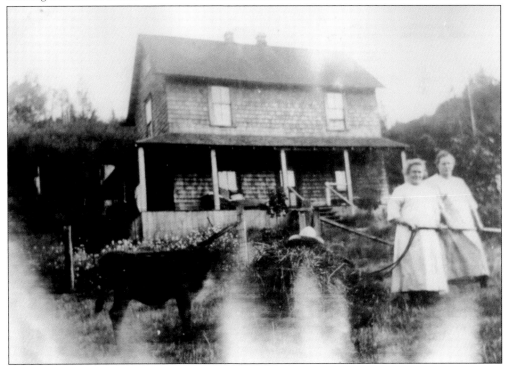

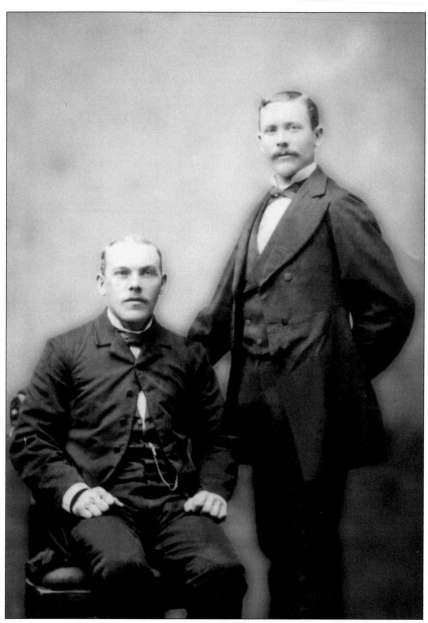

This 1884 photograph shows Gerhard Ericksen (left) and his friend Jacob Mohn about a year after they arrived in Bothell. Ericksen was 23 and Mohn was 28. Ericksen was a coppersmith who worked in Seattle for a time to earn money to purchase land. He located property a mile north of the river just south of the county line. He asked Mohn to help him improve the property he had purchased, then gave Mohn 80 acres as payment for his help. Bud Ericksen, Gerhard's grandson, remembers being told that Jacob and Gerhard surveyed the scene on the road facing their property that would become the Bothell-Everett Highway, and one said to the other, "This is certainly like Norway." By 1891, Ericksen had a prosperous general merchandise store on the corner of First and Main Streets. Ericksen's store made routine deliveries to settlements as far away as Silver Lake and Duvall on barely passable trails and logging roads, because he knew those folks would have starved without supplies.

This is a photograph of the Ericksens with five of their 10 children. Pictured are, from left to right, (first row) Gertrude, Gerhard, and Dorothea (on Gerhard's lap); (second row) Carlton, George, Dorothea (Mrs. Ericksen), and Martha. Martha died in a bicycle accident on the schoolhouse hill. The Ericksens were charter members of the Norwegian-Danish Evangelical Lutheran Molde Congregation of King County, which was named for the area they were from in Norway.

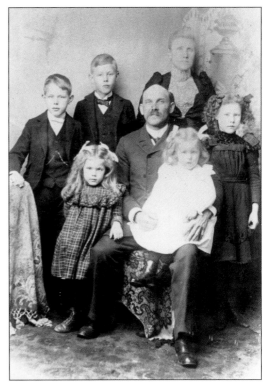

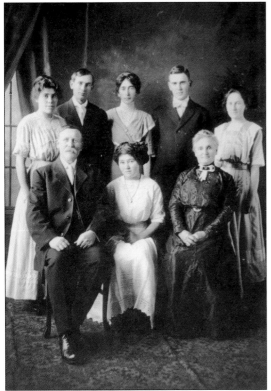

This photograph of the Mohn family was taken when the children were grown. They are, from left to right, (first row) Jacob, Adele, and Anna; (second row) Esther, Hanford, Agnes, Arnold, and Ragna. Jacob Mohn was a bookkeeper and opened a hardware and furniture store on Main Street. He served on the Bothell School Board and was a charter member of the Norwegian-Danish Evangelical Lutheran Molde Congregation of King County.

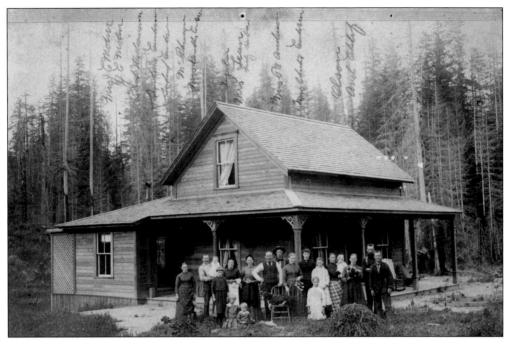

This 1888 photograph shows the Ericksen home one mile north of the town. Those who can be identified are, from left to right, Anna Mohn, Jacob Mohn (holding a baby), Ant. Williamson, grandma Anna Ericksen, Gerhard Ericksen, ? McPherson, Dorothea Ericksen, ? Ingebor, unidentified, Mrs. Leun, Mrs. Charlie Erickson, ? Olson, and A. Eklof.

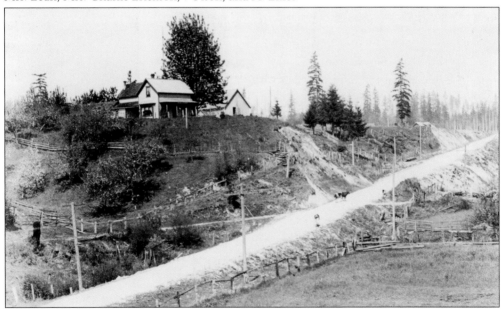

Jacob Mohn's family home was north of the Ericksen property across the county line. This home stood on 80 acres given to Mohn by Gerhard Ericksen for his help in clearing and improving Ericksen's property. The road in this 1886 photograph eventually became the Bothell-Everett Highway. This is the area that reminded Gerhard Ericksen and Jacob Mohn of their native Norway (as noted in a quote on page 18).

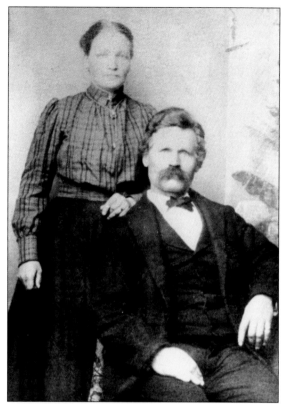

Andrew and Augusta Beckstrom settled north of the town with their two small children. They came up the river in a rowboat purchased from Mattias Bargquist. Augusta constructed a sail, so they did not need to rely only on rowing to navigate up the river. They found a homestead adjacent to Peter Quartman's property. The photograph at left shows Andrew and Augusta. The below photograph shows most of their family of 16 children. The children are, from left to right, (first row) Rudy and Albert; (second row) Bror, Augusta, Teddy, Andrew, and Stella; (third row) Tina, Julia, Ulrich, Selma, Carl, Inga, John, and Nina.

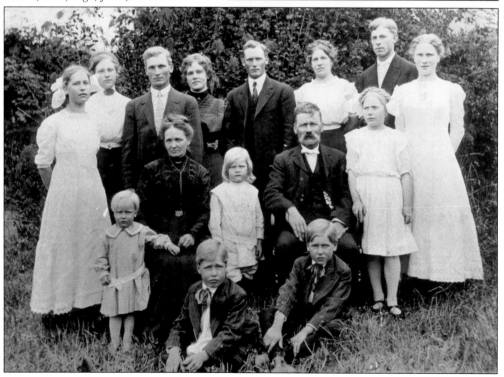

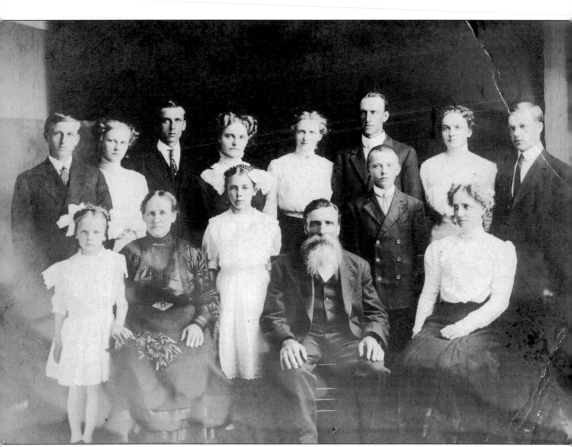

This photograph of the Peter Quartman family was taken before 1910. They were good friends and neighbors of the Beckstroms, who were fellow Swedes. Like the Beckstroms, the Quartmans had 16 children, but by 1910, only 12 were still alive. Seated in the front row seated are the parents, Martha and Peter. The young girl with her hand on her mother's knee is probably Mildred. Only the three older sons standing in the back row can be identified: Otto is on the far left, Frank is third from right, and Arvid is on the far right. Peter Quartman had a dairy on the hill above the town (where the St. Brendan Catholic Church now stands). Peter was a Lutheran, served on the school board, and was an active member of the community. He wore a three-piece suit every day and always had a beard.

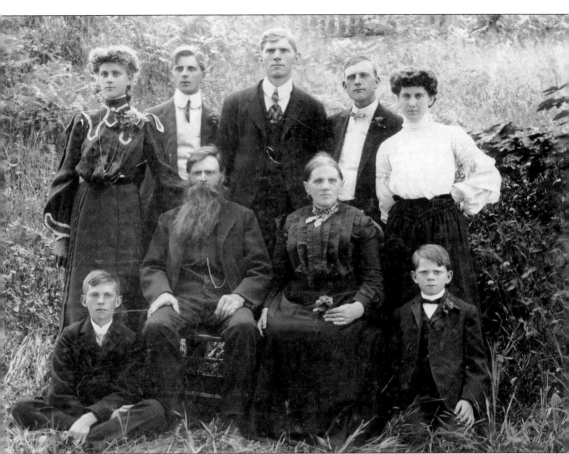

Alfred Pearson, born in Sweden in 1854, first homesteaded in Kansas but was not successful and worked in iron mines and railroads for a time. He came to the Sammamish River area in 1883, when he settled on the south side of the river on 40 acres on Norway Hill. Pearson was one of the founding members of the St. John Swedish Lutheran Church and started the Spring Hill Water Company to provide water from the Norway Hill springs. In this c. 1900 photograph, Pearson is seated in the middle with his second wife, Johanna. His stepson, Henning Pearson (the tall man standing in the middle of the second row), became the station agent for the Northern Pacific Railroad in Bothell for 47 years. Henning was the secretary of the St. John Swedish Lutheran Church until it disbanded in the early 1930s. In 1927 he wrote an article for the *Bothell Sentinel* to commemorate the 40th anniversary of the Seattle, Lake Shore & Eastern Railway coming to Bothell.

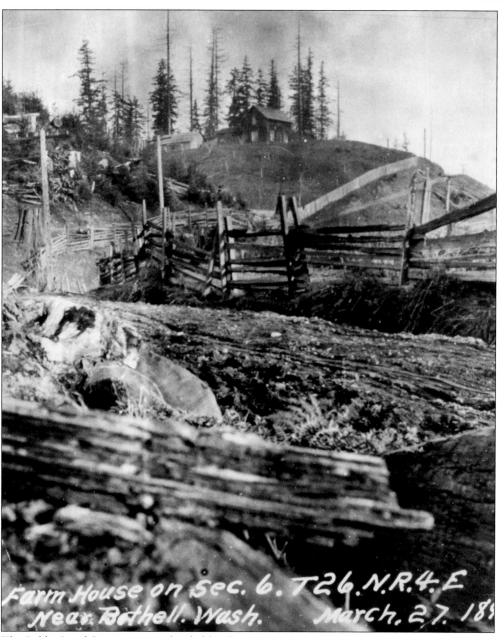

Farm House on Sec. 6. T26. N.R.4.E
Near Bothell. Wash. March. 27. 18?

The Public Land Survey system divided land into six-mile-square townships, and the townships were further divided into 36 one-square-mile sections. This photograph was taken on March 27, 1899, near Bothell and is misidentified as Section 6 of Township 26.N.R.4.E. The correct reference should be Section 6 Township 26.N.R.5.E. Section 6 is north and west of the original 1889 plat of the town of Bothell. This photograph was likely taken from the south end of the Everett Trail with a view looking up toward the north side of Westhill. Some of the pioneers who settled in this section included Gerhard Ericksen, Peter Peterson, and Charles Erickson. Others may have purchased or been given land on which to build a home by these property owners, and this unidentified farmhouse may belong to one of them. Section 6 can be found today just north of Pop Keeney Field.

David C. Bothell was born in Pennsylvania in 1820 and served in the Civil War. He married Mary Ann Felmley when he was 24, and they lived in Illinois, Missouri, and Iowa. He came to the Sammamish River area in 1884 with John and Rachel (Bothell) Keener when he was 64 years old. Bothell purchased 80 acres from James Brackett in 1884 and drove his oxen and the logging equipment from Seattle's Queen Anne Hill to the area that would become Lake Forest Park. He then cut his way through the forest to reach the area that he had purchased. In 1885, he had one team of horses, four cows, a few pigs, two dozen chickens, and three yokes of oxen. David and Mary Ann Bothell were well loved by the community and were affectionately known as Grandpap and Granny Bothell. Pioneers remember that in good weather, Grandpap and Granny would sit on the porch of the Bothell Hotel.

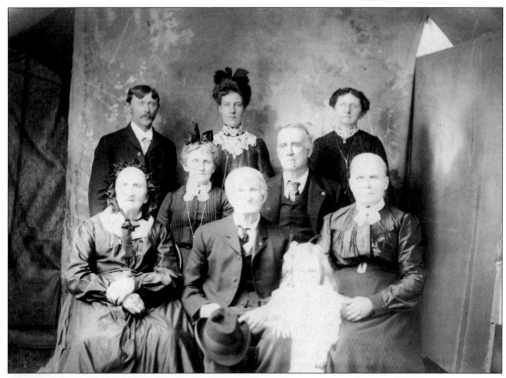

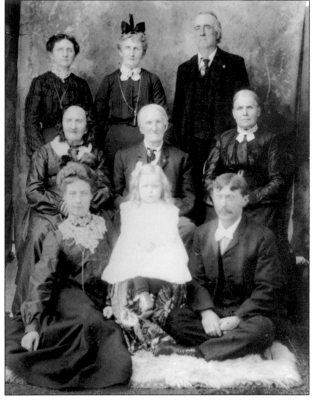

David C. and Mary Ann Bothell and family posed for these two formal photographs in 1903. In the above photograph are, from left to right, (first row) Mary Ann, David, Veulah Ball, and Mrs. Williams; (second row) Mary Ann Bothell Campbell and Robert Campbell; (third row) William Ball, Pearl Campbell Ball, and Rachel Bothell Keener. In the photograph at left are, from left to right, (first row) Pearl Campbell Ball, Veulah Ball, and William Ball; (second row) Mary Ann, David, and Mrs. Williams; (third row) Rachel Bothell Keener, Mary Ann Bothell Campbell, and Robert Campbell. Mary Ann Campbell is David and Mary Ann Bothell's daughter, Pearl Campbell Ball is their granddaughter, and Veulah Ball is their great-granddaughter. Rachel Bothell Keener is their daughter. Mrs. Williams is a relative of the Balls.

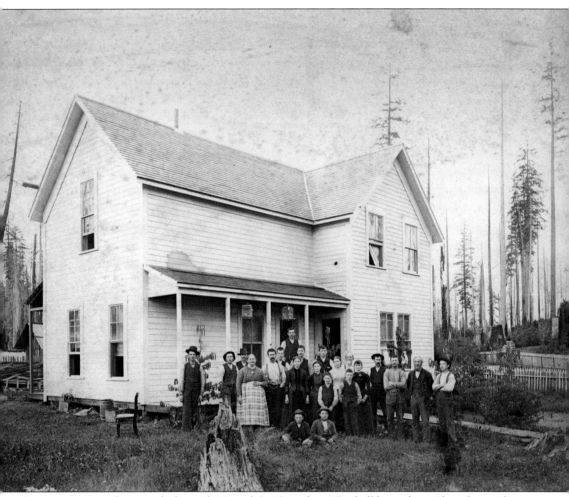

This 1887 or 1888 photograph shows the David C. "Grandpap" Bothell home located on the south side of Main Street near Third Street. Pictured here are, from left to right, Ambros Long, David Bothell, unidentified, Mary Ann (Granny) Bothell, John Keener, Adolph Larsen, unidentified, unidentified, Rachel Keener, Mollie Keener, Babe Keener, Fred Smith, Lida Wisinger, Bill Keener, Columbus Greenleaf, Francis Felmley, unidentified, John Bothell, John Felmley, and George "Allie" Bothell. The youngster sitting in the front at right is Curt Bothell. The other child is unidentified. Curt Bothell married Fannie Brackett, the daughter of James and Lizzie Brackett from Maine (and distant relatives of George Brackett). The Felmleys are related to Mary Ann "Granny" Bothell, whose maiden name was Felmley. Note the birdcages hanging on the porch roof and the stumps in the yard.

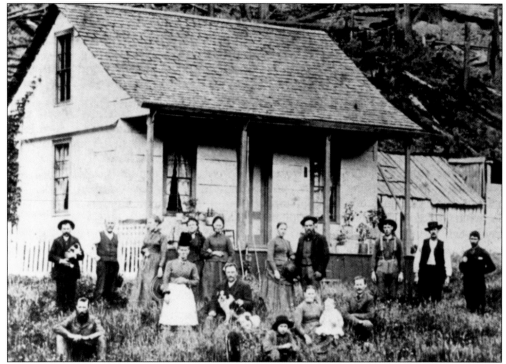

Peter Anderson was a painter who claimed 160 acres north of town across the county line in 1885. His wife, Emma, and his nine children farmed the land while Anderson worked as a painter doing government jobs in Nome, Alaska, and as far away as Guatemala, where he worked on the capital building.

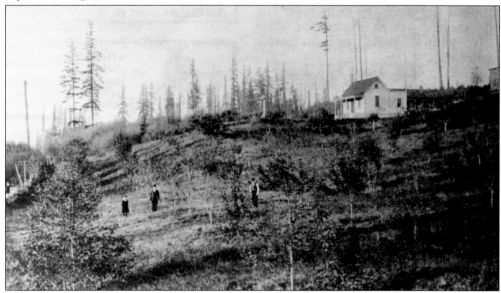

Marinus Ellefson came to the area in 1887 and lived on the Blyth property, where he worked as a construction contractor for the Seattle, Lake Shore & Eastern Railway. The Ellefsons bought 10 acres north of town from Charles Erickson and built the home shown in this photograph. Ellefson cleared the land at night and worked for the railroad during the day.

William A. Hannan, a bachelor from Michigan, first lived in a cabin on his homestead at Turner's Corner in Snohomish County. In 1888, Hannan bought four lots at the southwest corner of First and Main Streets and opened a general merchandise store. He met and fell in love with Jemima (Mima) Campbell, a granddaughter of David C. and Mary Ann Bothell. She promised to marry him if he would build her a house. He kept his word and built a Queen Anne–style house on Main Street between Second and Third Streets for his bride. This home was a few short blocks away from Hannan's store. The Hannans had two children who had fond memories of growing up on Main Street in Bothell. In 1977, the house built by William A. Hannan was moved to the Park at Bothell Landing, where it now serves as the Bothell Historical Museum.

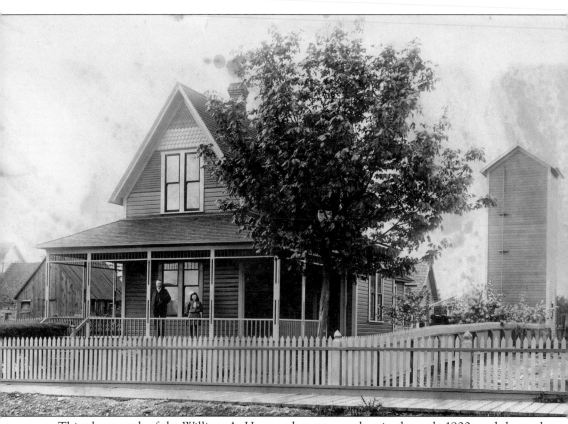

This photograph of the William A. Hannan house was taken in the early 1900s and shows the home he built for his wife, Mima Campbell. Standing on the porch are Hannan and his daughter Gladys. To the right of the home is a water tower. Another request that Mima had was for running water; William had a well dug and pumped the water up to the water tower, and when the tap was turned on, gravity caused the water to flow. The water was then heated inside the house. The house had a bathroom with a washstand and bathtub but no toilet. The toilet was an outhouse on the property. Hannan's store was a few blocks west of this house, and his horses and buggies were kept at the store.

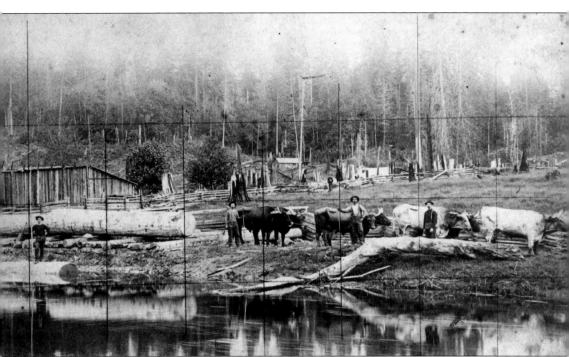

This 1880 photograph shows an early oxen-based logging operation on the John Blyth property. The logs were rolled into the river and floated out to Lake Washington and onward to mills along the lake. Logging helped clear the land for farming while providing building material and income from the sale of the timber. This scene was probably captured with a panoramic camera and printed as a horizontal scroll. According to the 1880 agricultural census, Blyth had 145 acres of woodland and forest, 13 acres of tilled land, and 10 acres of permanent meadows, pastures, orchards, and vineyards. At that time, the value of the farm was $800, and the value of the livestock was $200. That same agricultural census lists eight other men farming along the Sammamish River. From that list, only Columbus Greenleaf was still farming in the area in 1900.

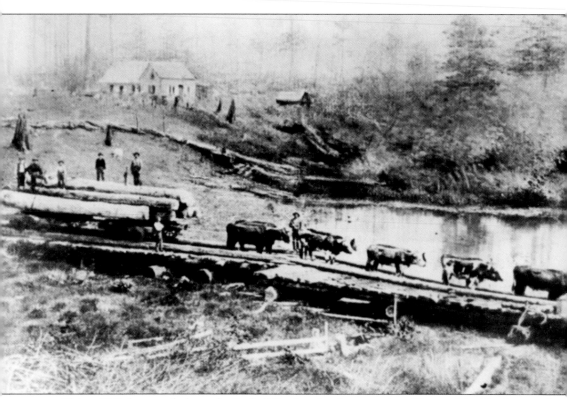

This c. 1885 photograph shows the Bothell Brothers logging operations. The track in this photograph was built with pole rails and ran from the area of what became First Street down to the river. Early loggers used oxen to yard (move) the logs. In this photograph, it is possible to see the rough wheels used to carry the logs down the track. Once the logs entered the river, it took about a week for them to reach Lake Washington. Near the upper left of the photograph is the Bothell boardinghouse, which was built around the same time the logging operation started up. It is likely that the boardinghouse provided a home for many of the loggers employed in this operation.

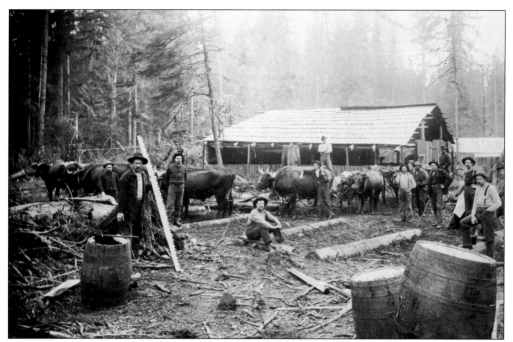

This early logging photograph shows the work of yarding done by oxen. The line of timbers in the center of the photograph gives the loggers a track for the logs to slide on. The location of this operation is unidentified, but it is likely that the river, where the logs would be dumped, is off to the right.

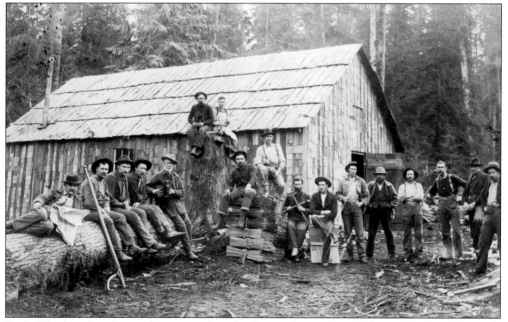

Bothell had an abundance of first-growth cedar that made excellent shakes, as shown in this early cedar shingle mill. Hand-split shakes are superior to sawn shakes because rainwater runs down the natural grooves in the wood. A shake is split off the end of a bolt of cedar, then upended before another shake is split. This procedure is repeated until the bolt is completely used.

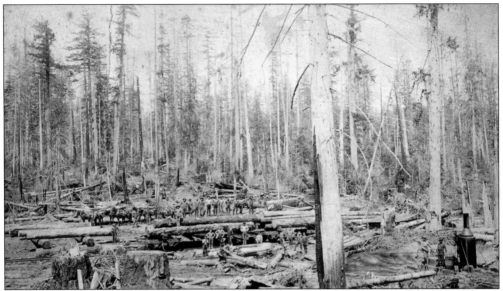

The Huron Mill, located south of the town center, was platted as Windsor/Huron. A boardinghouse, store, and mill were quickly erected, and by 1888, up to 100 men were employed at the mill. Many of the men purchased acreage in the area and were able to support families. In 1890, the mill was sold to a Mr. Fleming and Charles and Ed Ayrst, who ran the mill until a fire destroyed it in 1894. The owners asked the townspeople to donate labor to clean up and sort materials for rebuilding. The town donated many hours of work for this venture. However, instead of rebuilding the mill in Bothell, the owners moved everything to Bellingham. The town of Windsor/Huron disappeared and now can be only be found on old maps. These two photographs show the logging operation (above) and the camp.

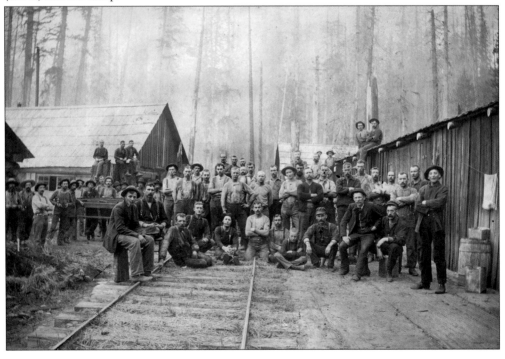

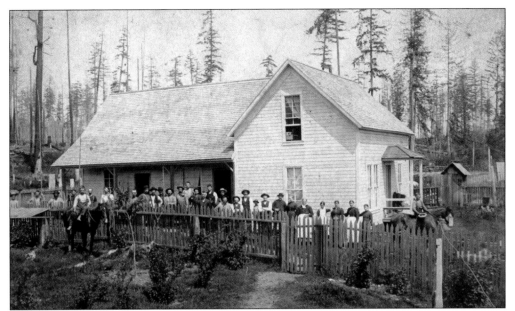

This very early photograph shows David Bothell's boardinghouse, which was built around 1885. The 23 men shown here probably worked in the Bothell Brothers shingle mill or as loggers in the forests. After the boardinghouse burned in 1895, Bothell built a hotel in the same location and arranged for his daughter and son-in-law, John and Rachel (Bothell) Keener, to manage it.

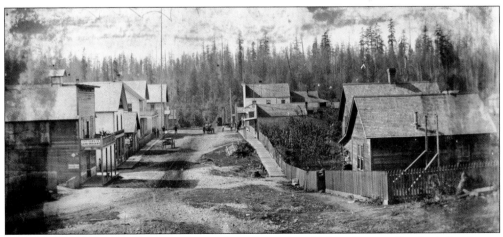

This early photograph offers a view west from Second and Main Streets. On the left side are, from bottom to top, Geo. Dawson Cash Grocery, Odd Fellows Hall, Webster's Blacksmith Shop, Keener's Bothell Hotel, and W.A. Hannan's store. On the right side are, from bottom to top, Cain and Lytle's cookhouse, Grandpap Bothell's garden, Severance Bakery, Hoff and Johnson's shoe shop, and Gerhard Ericksen's General Merchandise.

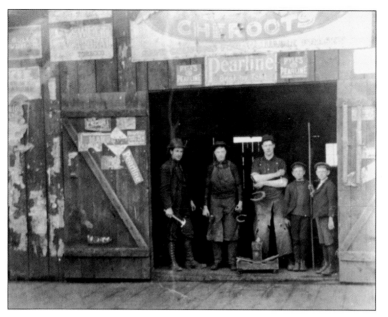

Webster's blacksmith shop was located on Main Street next to the Odd Fellows Hall and right across the street from Grandpap Bothell's garden. The blacksmith shop burned in the 1908 fire, and another business took over this spot. Much later, from 1957 to 1971, it was a Ten Cent store managed by Dave Johns, father of US senator Patty Murray.

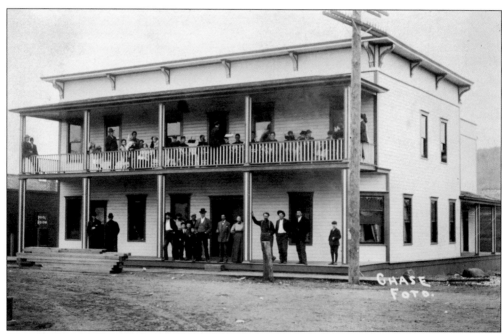

The Bothell Hotel was built in 1895 on the corner of First and Main Streets on the former site of the David Bothell boardinghouse. The hotel was operated by John and Rachel (Bothell) Keener. Room and board was $5 per week. David C. "Grandpap" and Mary Ann "Granny" Bothell would sit on the porch when the weather was nice.

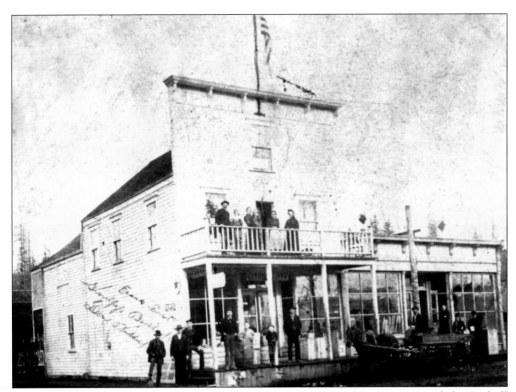

This 1892 photograph shows Gerhard Ericksen's store, the family's quarters, and the Bothell Post Office. Standing on the balcony are, from left to right, Gerhard Ericksen, George Ericksen, Dorothea Ericksen (holding son Carlton), Aunty Williamson, and Anna Ericksen. On the street are, from left to right, David Bothell, D.C. Bothell, Frank Frost, Jim Brackett, Charles Wilson, William Mortenson, Fred Smith, S. Furre, Olivia Cole, a Mrs. Rossford, and Sarah Burdick. The below photograph shows the Ericksen delivery wagon with an unidentified driver and two boys sitting with him. Ericksen's General Merchandise made deliveries as far away as Duvall and Silver Lake.

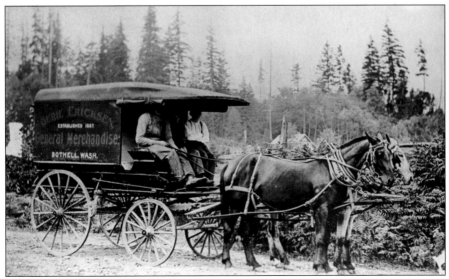

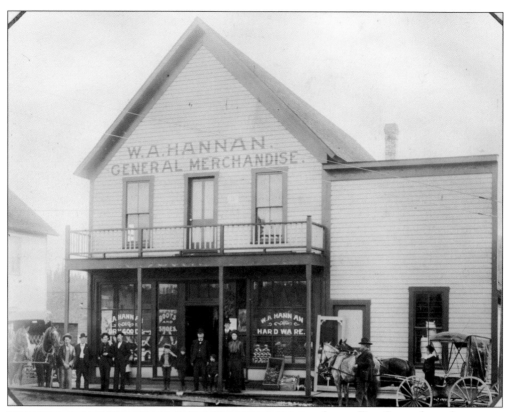

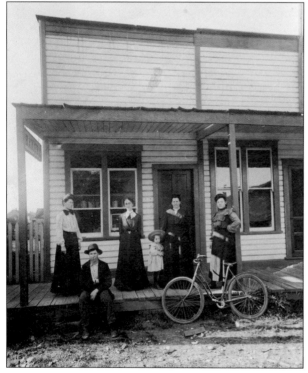

Across First Street from the Bothell Hotel was the W.A. Hannan General Merchandise store. Hannan lived a few blocks east with his family. This 1900 photograph shows Hannan standing in the doorway. To his right are clerk Charles Wilson and Clara Bothell. This wooden structure was destroyed in the 1908 fire.

The Severance Bakery was opened by Bessie Severance around 1900. It was located on the north side of Main Street. Severance is shown standing in the doorway. The rest of the people in this photograph are unidentified, but some of them may be her children. This building burned in the 1911 fire, but Severance was able to find other locations for the bakery, because it remained in operation for 36 years.

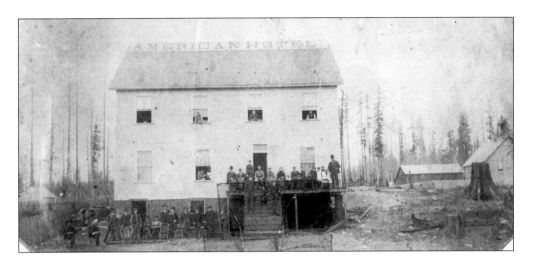

John Rodgers built the American Hotel in 1888 at the corner of First and Fir Streets, just a short block north of Main Street. The above photograph shows the hotel just after completion. The below image shows the hotel after a porch had been added; Rodgers is standing on the porch with a child that may be one of his children. A livery stable, restaurant, and bar were also added, and the hotel had a carriage that met every train that stopped at the Bothell depot. In the below photograph, a new telephone pole can be seen just right of the hotel building. The hotel contained the first telephone exchange, which opened about 1895. Rodgers's wife, Mary, was the first switchboard operator.

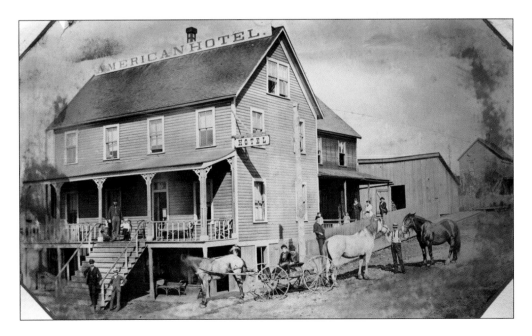

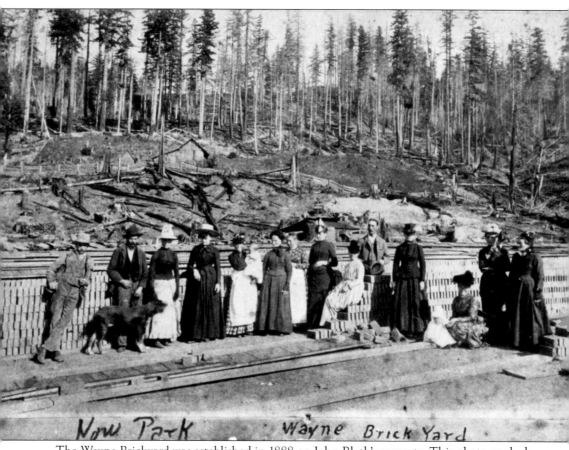

Now Park Wayne Brick Yard

The Wayne Brickyard was established in 1888 on John Blyth's property. This photograph shows a group of friends who were attending a party at the Blyth home nearby and strolled over to the brickyard for a picture. They are, from left to right, Joseph Blyth, John Blyth, Christina Blyth, the Blythes' unidentified hired girl, Anna Mohn (holding her son, Hanford), Anna Ericksen (mother of Gerhard Ericksen), Mrs. Andrew Fatland, unidentified, unidentified, unidentified, unidentified, Mrs. Peter Peterson (sitting with child), unidentified, and Mrs. Charles Erickson. Joseph, John Blyth's elder brother, owned some property in Bothell and provided the land to build Bothell's second schoolhouse. He later suffered from mental illness and drowned himself in the Sammamish River in 1893. The brickyard closed in the 1890s. Blyth Park is now located on this site.

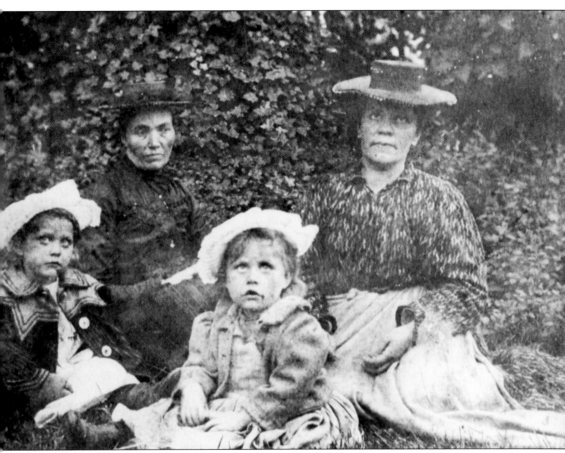

At 5:30 a.m. on July 3, 1902, notorious escaped killer Harry Tracy was spotted heading toward Bothell. The citizens of Bothell were warned and ready. According to Vincent Hohmann, who was nine at the time, "Everyone was armed and hunting Tracy. I too carried a huge cap gun which seemed to give me a feeling of great security." Tracy arrived at Wayne on July 3 and stopped at the Bargquist home. Annie Bargquist was alone with her daughters, Matilda "Tillie," age five, and Bertha, age three. Bertha and Tillie hid under the table while their mother was fixing food for Tracy. Bertha described that day in detail about 70 years later: "My sister (Tillie) and myself were scart when he stood in our kitchen door . . . Tillie and I were under the kitchen table." In this photograph, from left to right, are Matilda "Tillie" Bargquist, Christina Blyth, Bertha Bargquist, and Annie Bargquist.

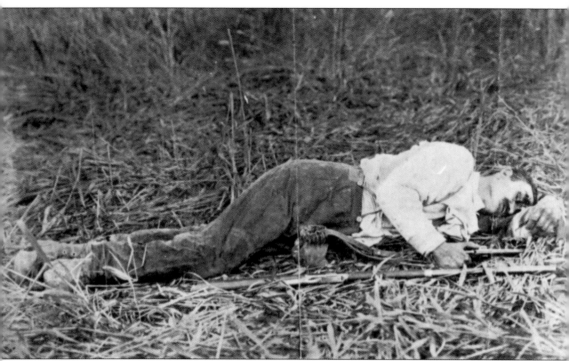

After escaped convict Harry Tracy left the Bargquist home, he hid in some outbuildings on the property, possibly overnight. He then crossed the river to the area that is now the west side of Wayne Golf Course and took refuge in a small cabin near the railroad tracks. The next day, a rainy July 4, an armed posse was walking on the tracks toward Wayne from Woodinville. At Wayne, they spotted a cabin near the tracks and circled it. About 30 feet away, Tracy came out shooting from behind a large stump. In a few minutes, two men lay dead and one was wounded. Tracy escaped into the dense woods. John Rodgers and Charles Hohmann, Vincent's father, showed great bravery by hitching up a wagon and heading to Wayne to pick up the dead and wounded. Tracy made his way to back Seattle and then to Eastern Washington, saying he wanted to reconnect with Butch Cassidy's Hole-in-the-Wall Gang. He continued to elude capture until August 6, 1902, when he committed suicide—rather than be captured alive—while surrounded in a wheat field.

Two

A New Community

Churches, schools, bands, and sports teams helped draw folks together, and a town doctor helped to build the community. The Methodist Episcopal church began in 1885 at the home of David C. and Mary Ann Bothell. Columbus Greenleaf provided his home as a meeting space for the Norwegian-Danish Evangelical Lutheran Molde Congregation of King County (Norwegian Lutheran church). The Swedish Lutherans organized at the Alfred Pearson home on Norway Hill. By 1900, all three churches had buildings within steps of each other. For that reason, the area of town bounded by Second, Third, Main, and Pine Streets was called Gospel Hill.

Before 1885, small schools in different areas of the community served the children of Bothell. The founding families petitioned the county and were awarded a school district, authorizing Bothell to provide education for its children. The first school building was a one-room schoolhouse built on Main Street for grades 1 through 8. Helen DeVoe was hired to teach for $40 per month, and school opened on March 29, 1886, with 23 pupils. This schoolhouse quickly became too small for all the schoolchildren, so in 1890, Bothell's second schoolhouse, a two-story structure with a bell tower, was built at the top of the hill on First Street. In 1907, the second schoolhouse was replaced by the third school building on the same property. At that time, Bothell added high school education and the high school students studied on the second floor, the grade school students on the first floor. In the 1920s, a high school was built west of the Schoolhouse Hill across the Bothell-Everett Highway. Today, this is the site of Pop Keeney Stadium and McMenamin's Anderson School complex.

Music and sports were important to the citizens. The first town band, the Rialto Band, was formed before 1897. The Rialto was followed by the Bothell Town Band (around 1904), and the Bothell Cornet Band, which had its own band hall. Hotelier John Rodgers owned a professional baseball team—the Bothell Regulars—made up of community members and hotel staff. Later, the Methodist Episcopal church fielded a team and another team, the Bothell All-Stars, was active during the early years of the 20th century.

In 1889, Dr. Reuben Chase, a Civil War veteran, was looking for a town that needed a doctor. Bothell was suggested since it had no doctor and was, at the time, suffering through a typhoid epidemic. Dr. Chase settled in the Stringtown area and became a beloved part of the community.

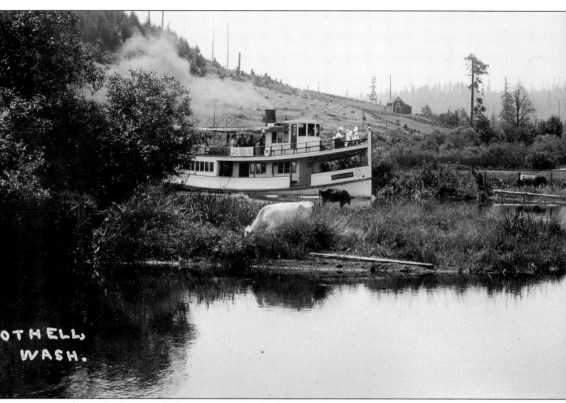

OTHELL, WASH.

In the early days, Bothell was accessible by boat, and then, after 1887, by train. This early-1900s photograph shows the steamer *May Blossom* heading toward Seattle on what looks like a beautiful, sunny spring day. It is traveling through the Blyth farmland at Wayne. Several women dressed in finery with large hats are enjoying the view of Norway Hill. The hill in the right background is Finn Hill, which is now part of Kenmore. According to the *Bothell Sentinel,* from May 1, 1908, to November 1, 1908, there were 21,400 passenger trips by steamer over the Sammamish River. The price for a trip to Seattle was 25¢ one way and took about 1 hour and 40 minutes. Train travel was faster but cost more and was not as scenic. Carlton Ericksen, son of Gerhard Ericksen, recalled the beauty of Bothell in a 1967 interview: "You're on that steamer and you think you're in paradise."

The Norwegian-Danish Evangelical Lutheran Molde Congregation of King County church was built on property purchased from David Bothell from his original plat of the town. This photograph shows the parsonage (left), built in 1908; the church, (center), built in 1891; and the parish hall (right), built in 1931. Molde, part of the church's original name, was the hometown of Gerhard Ericksen and Jacob Mohn. The church still maintains a relationship with its sister congregation in Molde, Norway.

Members of the Norwegian-Danish Evangelical Lutheran Molde Congregation of King County pose for a photographer in front of the church in May 1910. Rev. John Olaus Dahle (lower left corner) is holding his eldest son, Jofred. Behind him is his wife, Thora. Reverend Dahle arrived in Bothell in 1908 and conducted services in Bothell, Juanita, Redmond, and Novelty.

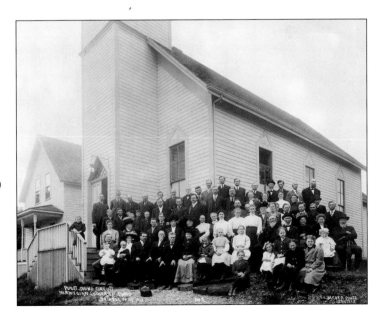

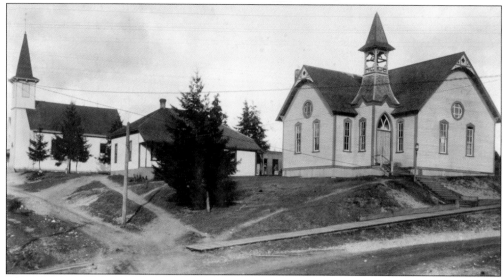

The Norwegian Lutheran church (left) and the Methodist Episcopal church shared a block bordering Main Street. The first church built in the area was the Norwegian Lutheran church, which was erected in 1889. The Methodist Episcopal church was built shortly after that. The Norwegian Lutheran church is still in the same location today. The Methodist church moved to a new building on Westhill in 1958.

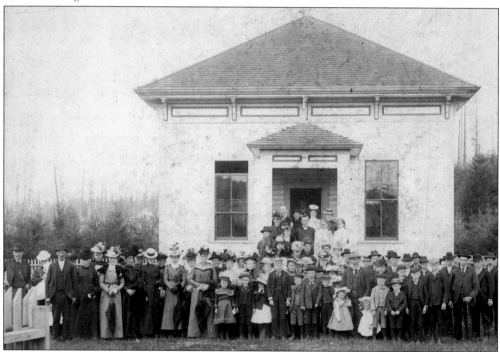

The St. John Swedish Lutheran Church was built at the corner of Third and Fir Streets. The church suffered dwindling attendance during the 1920s, and by the early 1930s, it had only 35 members. In 1931, the church was disbanded, the building was sold, and the proceeds were sent to the old folks' home managed by the Columbia Swedish Lutheran organization. The associated cemetery is still in Bothell.

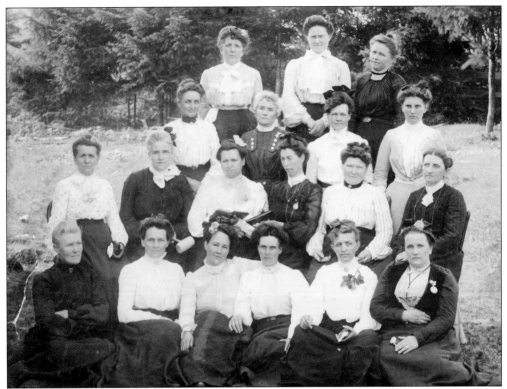

This c. 1903 photograph shows the Methodist Ladies' Aid Society. The members are, from left to right (first row) Dorothea Ericksen, Catherine Chambers, a Mrs. Buck, Belle Bothell, Mary Burgess, and Rebecca Hargus; (second row) Rosanna Bosley, Della Ross, Bessie Severance, Anna Reder, Margaret Dutton, and Rachel Keener; (third row) Emma Ellis, Flora Eason, Margaret Crumly, and Edith Hargus; (fourth row) a Mrs. Fox, Lena Bothell, and Mary Durham.

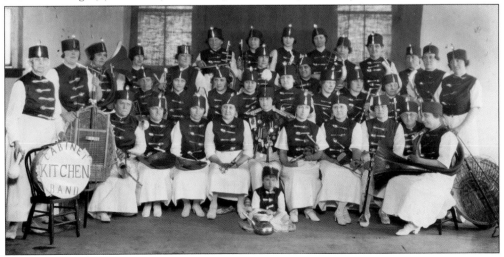

The Kitchen Cabinet Band, a group of ladies from the Methodist church, put on a benefit show in 1926. The band presented a musical evening with solos, duets, and quartets all accompanied by the utensils found in their kitchens. Some of the instruments included eggbeaters, brooms, kettles, and washtubs. One woman even wore a vacuum cleaner around her neck.

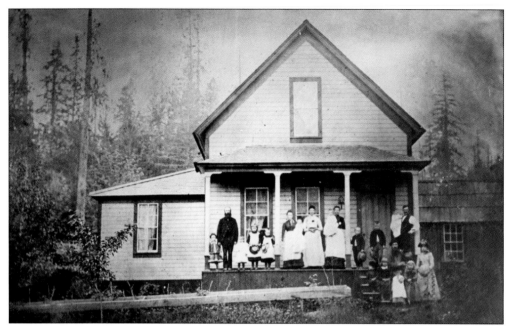

Two of the early schools in the area were north of town. The above photograph shows the Bartleson homestead, where August Bartleson built a school. The Bartleson School had up to 20 pupils. In 1887, Bartleson and Jacob Mohn petitioned the new school district to take this school into the district. The below photograph shows the North Creek School located in the Canyon Park area. This school became part of the new Bothell district in 1887. The North Creek School closed in 1920 and the building served as a community center for a time. In addition to these schools, David C. Bothell hosted a school in his home for a time, and the Woodin home also provided a school.

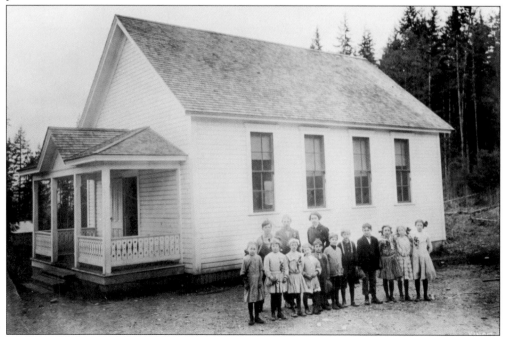

The first schoolhouse in Bothell was built in 1885, and Helen DeVoe was the town's first teacher. It opened with 23 pupils for a three-month term. After the term was over, the school board decided to continue the school another month. The students were apparently happy about this, since they decorated DeVoe's desk with dog-tooth lilies from the banks of the Sammamish River.

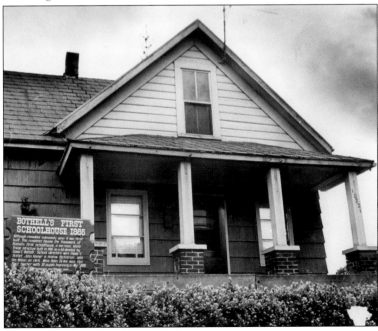

The first building constructed by the new school district was a one-room schoolhouse that quickly became too small for the number of children in the town. After the second schoolhouse was built, the original schoolhouse became a residence. In 1989, it was acquired by the city and moved to the Park at Bothell Landing; it is now part of the historical museum complex.

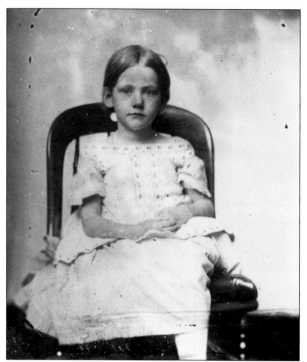

Helen DeVoe, the beloved first teacher in Bothell, came to the area with her mother in 1885. They carried their belongings four miles north on the Everett Trail to her homestead in Snohomish County. The tintype at left shows Helen as a young girl in Homer, New York. The below image shows her at age 53 attending the Alaska-Yukon-Pacific Exposition. Although DeVoe left Bothell to teach in areas as far away as Alaska, she maintained her ties to the community. When George Wilson died in 1916, he left a good portion of his library to DeVoe. DeVoe died in Seattle on February 11, 1954, at the age of 97.

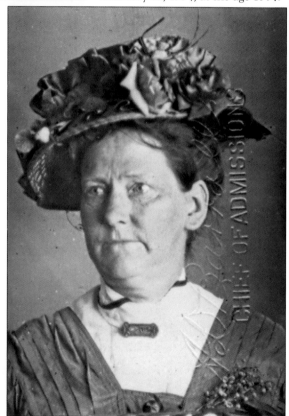

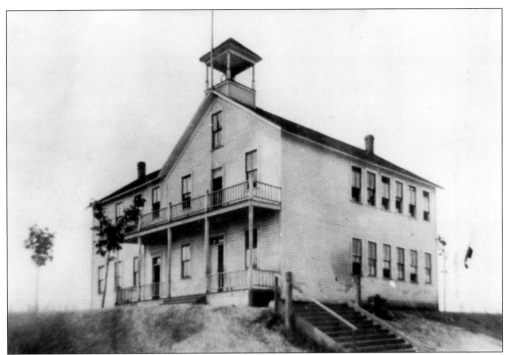

Bothell's second schoolhouse was built in 1890 on land acquired from Joseph Blyth. This land was at the top of First Street, which quickly became known as Schoolhouse Hill. The cost to build and open this school was as follows: building—$1,557.50; furniture—$210; clearing lot—$10; clearing, fencing, and cutting trees—$65.25; blackboard cloth—$12.50; twenty yards of paper—$1; labor for putting in seats—$7.50; recording the deed—$1.25; draft—30¢; insurance—$32; and lumber, posts, and hauling for the fence—$54.84. The note written by Joe Blyth on the back of the below photograph dates it to 1906, when he was nine years old and in the third grade. Joe was the adopted son of John and Christina Blyth.

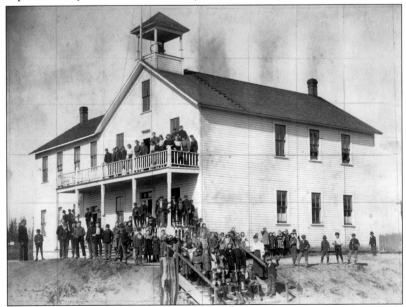

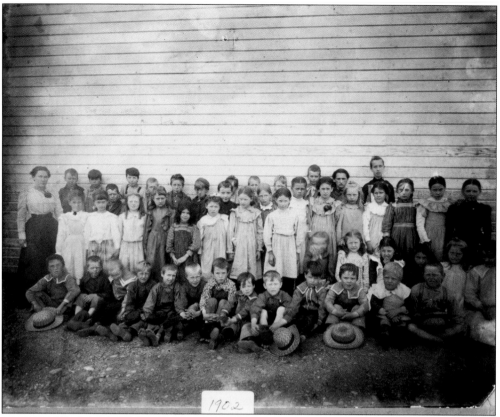

This 1902 photograph, taken outside Bothell's second schoolhouse, shows the 46 grammar school students with their teacher, Stella M. Anderson. Among those in this group are four Bothells, three Mohns, two Beckstroms, two Quartmans, two Rodgers, a Campbell, and a Pearson—all pioneer family children. At least one child in the photograph is barefoot.

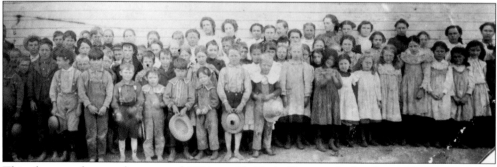

This photograph was taken around 1904 outside Bothell's second schoolhouse. There were four schoolrooms, and each had a stove; the pupils usually brought wood from home. Water was carried in from a nearby well, and all pupils drank out of the common dipper. Note that some of these children are barefoot.

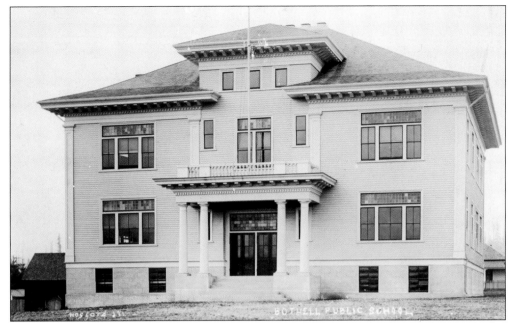

Bothell's third school building was built on the hill in 1907 and operated until the 1920s. This school served high school students on the second floor and grade school students on the main floor. In 1907, there were 8 ninth graders and 5 tenth graders. Henry Simonds, the principal, also taught all grades. His office is in the center of the top floor, just behind the flagpole.

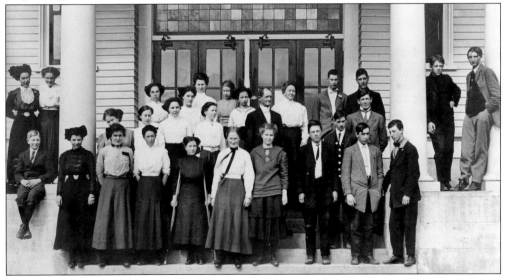

This May 5, 1911, photograph shows Bothell High School students and principal standing on the steps of Bothell's third school building. Pictured are, from left to right, (first row) Claude Dutton (seated beside pillar), Mary Armor, Georgia Turple, Zela Roomer, Mary Stewart (with crutches), Nina Beckstrom, Esther Simonds, Orin Linz, Harry Reder, and Almon Hannan; (second row) Ethel Cotton, Erma Olin, Ethel Pearson, Bertha Dutton, Professor Simonds, Thad Gardner, and Atlee Hollingsworth; (third row) Maud Hull, Sarah Simonds, Esther Wright, Carrie Ross, Merle Olin, Agnes Mohn, unidentified, Josephine Harrington, Herbert Oliver, Glen Bailey, M.K.M., and Paul Victor.

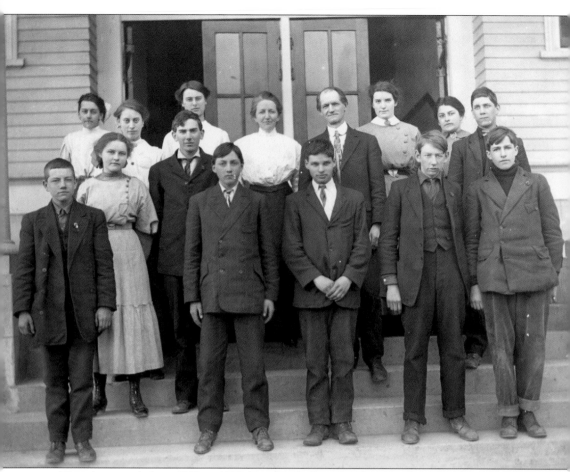

This photograph from 1909 or 1910 shows Bothell High School students standing on the school steps with their principal, Henry Simonds. Pictured are, from left to right, (first row) Orin Linz, Sarah Simonds, Harry Jones, Byron Vance, Vincent Hohmann, Joe Blyth, and Russell Blackburn; (second row) Carrie Vangemert, Erma Olin, Merle Olin, teacher Josephine Harrington, Principal Simonds, Carrie Ross, Mary Hollingsworth, and Glen Bailey. Sarah Simonds, the daughter of Henry Simonds, married Charles Green, who established Bothell's first automobile repair shop and, later, Green Motors. Joe Blyth inherited the Blyth property at Wayne and created Wayne Golf Course in the 1930s. He provided the land for Blyth Park and sold the land that eventually became the Valhalla and Riverbend neighborhoods. Joe Blyth and Matilda Bargquist were married in 1949.

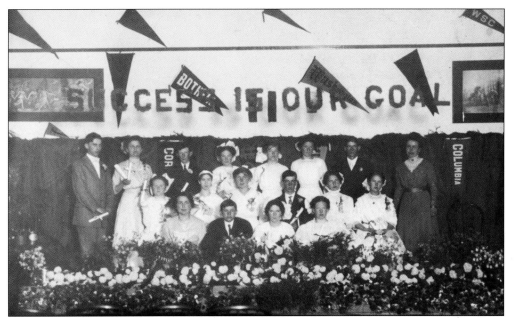

"Success Is Our Goal" was the class motto of the eighth-grade graduates of 1911. College pennants from Washington and Washington State are displayed. Pictured are, from left to right, (first row) Nellie Hollingsworth, Francis Gregory, Grace Bartels, and Pearl Weeman; (second row) Josephine Gamble, Vivian Wallace, Lena Hollingsworth, Ollie Davenport, Lenora Hohman, and Gertrude Walcott; (third row) Ross Worley, Hulda Nelson, Virgil Askren, Ragna Mohn, Elsie Hansen, Mazie Roomer, Gerald Cooper, and teacher Jeannie Neevil.

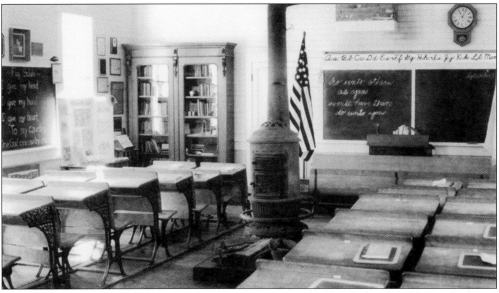

This 1920 photograph is believed to show a classroom in the third school building, which was built in 1907. It shows the slates on the desks and the woodstove. Text on the left side of the blackboard reads, "Flag Salute—I give my head; I give my hand; I give my heart, To my Country; One God, One Country, One Flag."

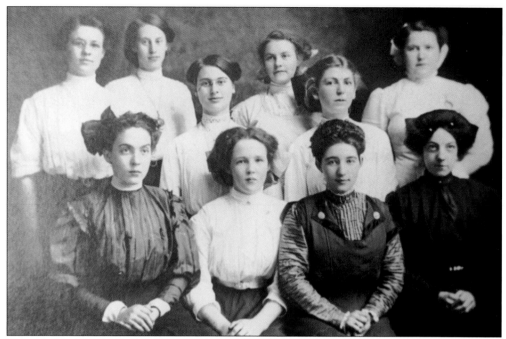

These girls of the Bothell High School classes of 1910 through 1912 are, from left to right, (first row) Maude Hull, Irene Campbell, Viola Cooper, and Anna Kilmer; (second row) Eunice Crumly, Erma Olin, Merle Olin, Sarah Simonds, Lena Hollingsworth, and Bertha Severance.

The members of the graduating class of 1912 were all women. Dr. Emma Beddow, the town's dentist, played a piano solo for the graduation ceremony. This photograph shows cast members dressed for their roles in a play called *Women's Rights*. Pictured are, from left to right, (first row) teacher Harriet Wray, Sarah Simonds, and Erma Olin; (second row) Carrie Ross, Merle Olin, and Nina Beckstrom.

The 1914 graduates shown at their class picnic are, from left to right (first row) Almon Hannan, Claude Dutton, Joe Blyth, and Merrit Martin; (second row) Maude Hull, Ethel Pearson, Esther Simonds, and Blanche Morton. Hannan, the son of William A. Hannan, became the postmaster in Bothell from 1934 to 1954.

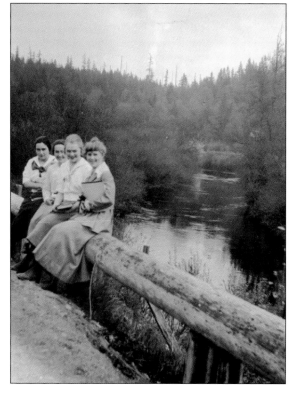

Four girls from the 1918 Bothell High School graduating class are shown sitting beside the river. They are, from left to right, unidentified, Vernie Miller, Gudron Ormbrek, and Mary Armor. Ormbrek's great-uncle's family settled in east Juanita, which became part of Bothell in 2014 and is now the Queensgate development.

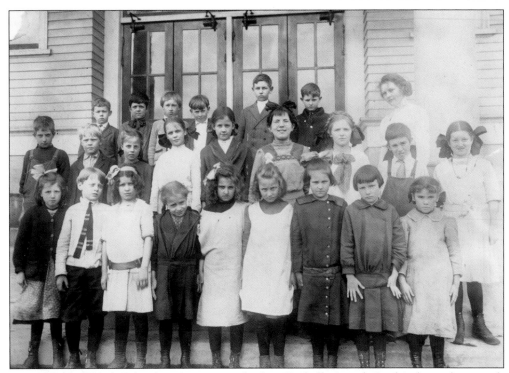

Several Bothell High School graduates came back to Bothell to teach. In the above photograph is a class of elementary school students with their teacher, Sarah Simonds. This photograph was most likely taken before 1916, when she married Charles Green. The 1923 photograph below shows a group of second-grade students with their teacher, Bertha Bargquist. She is the woman on the left in the back row. A list of pupils was found with the photograph but it is not possible to match the names with the students pictured. The students include, in alphabetical order, Cornelius Askren, Vern Bartleson, Gwen Beckstrom, Marge Beckstrom, Marge Conner, Edith Crowe, Saburio Dei, Don Edge, Bud Ericksen, Ozzie Goethals, Elizabeth Gorman, Margrete Hawley, Mary Hawley, Flo Hosmer, Almay Jones, Melvin Labar, Jamie Mohn, Ferd Simonds, Max Stockinger, Bob Walters, Milton Worley, and Rich Worthington.

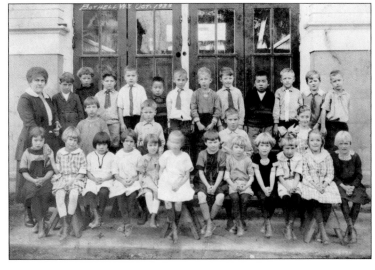

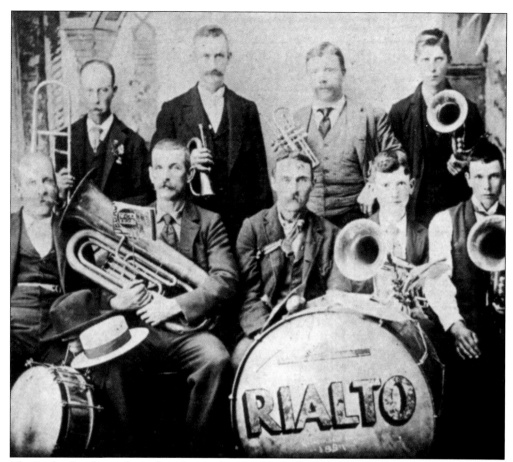

The Rialto Band was the earliest known band in Bothell. This 1897 photograph, probably taken in a photography studio, shows the band members and their instruments. From left to right are (first row) James Brackett, Alvin Rodgers, William Bell, Robert Renchy, and James Hargus; (second row) Lawrence Rhea, Charles V. Beardslee, unidentified, and Gus Pearson.

John Rodgers built the American Hotel in 1889 on the northwest corner of First and Fir Streets. This photograph, taken sometime before 1902, shows the Rialto Band posing in front of the hotel. The Rialto Band got its name from the old bass drum members acquired from a band in Seattle.

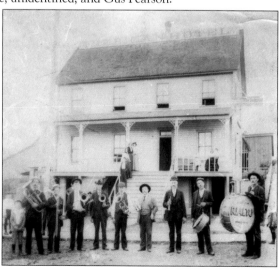

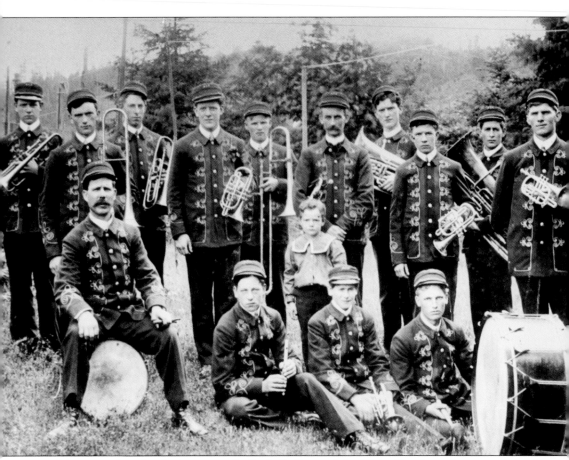

Music continued to be important in Bothell. Some of the Rialto Band members were joined by others to create the Bothell Town Band. This 1905 photograph, taken in Bothell by C.A. Fox, shows the Bothell Town Band members. From left to right are (first row) Bill Snudden, Forbes Chambers, Hanford Mohn, and Ulrich Beckstrom; (second row) Avery Hall, Boyd Hargus, John Beckstrom, unidentified, Dan Hall, Charles V. Beardslee (leader) , Robert Renchy, William Wilson, Reuben Young, and Henning Pearson. The young boy standing in the middle is William Beardslee, son of Charles V. Beardslee. Charles Beardslee was an ardent music lover and actively recruited more band members.

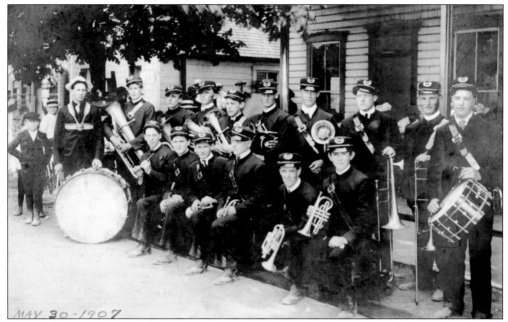

This May 30, 1907, photograph of the Bothell Cornet Band was taken in front of the Bothell Hotel at First and Main Streets. The band members are, from left to right, (first row) George Bothell (bass drum), Reuben Young (bass horn), Forbes Chambers (piccolo), Arnold Mohn (clarinet), Jack Burns (cornet), Hanford Mohn (leader, cornet), L.B. Stingley (cornet), and George Wilson (cornet); (second row) Robert L. Denton (baritone), Boyd Hargus (BG bass), Carlton Ericksen (alto horn), Carl Beckstrom (alto horn), John Beckstrom (alto horn), Dan Hall (trombone), Ulrich Beckstrom (trombone), and George Arunspicer (snare drum).

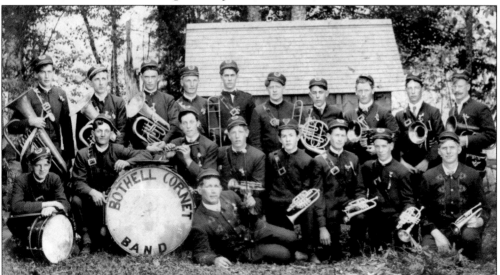

The Bothell Cornet Band built its own hall and opera house, and Prof. J.H. Wilelm of Seattle gave lessons in Bothell every Friday. In December 1908, the band elected officers for the following year. They were Hanford Mohn (president), Ulrich Beckstrom (vice president), Carl Beckstrom (secretary), Z.F. Burns (treasurer), L. Denton (librarian), Hanford Mohn (leader), and George Wilson (assistant leader).

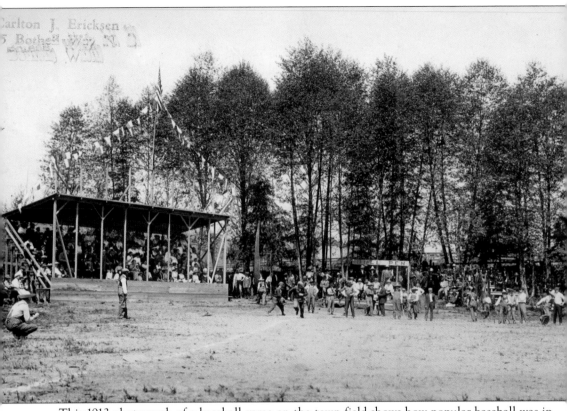

This 1913 photograph of a baseball game on the town field shows how popular baseball was in Bothell. This field is close to the present-day location of the Park at Bothell Landing, and it was donated by businessmen for the use of the community. The field has a bullpen and bleachers. Bothell had a professional baseball team as early as 1903; the team was called the Bothell Regulars and was owned by John Rodgers, proprietor of the American Hotel. Rodgers recruited players from the community and from his hotel staff. The Methodist church had a team that played in a league of teams throughout the area. Another team, the Bothell All-Stars, played locally until a death cast a pall over the town when one of the team's star players was killed by a pitched ball to the head during a game with Woodinville.

This 1903 photograph shows the Bothell Regulars, a professional team owned by hotelier John Rodgers. Pictured are, from left to right, (first row) Todd Schroeder (catcher), Billy Blackburn (mascot), and Mose Olney (pitcher); (second row) Alec Blanchard (fielder), George Briggs (catcher and fielder), Hanford Mohn (all positions), and Jack Clark (third base); (third row) ? Blackburn (active in team affairs), George Bothell (fielder), Norman Short, ? Gillespie (first base), Charley Sheets (second base), and Rodgers.

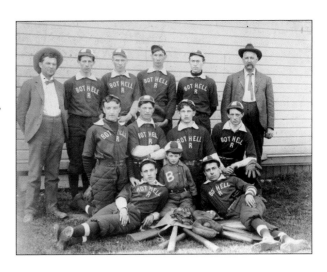

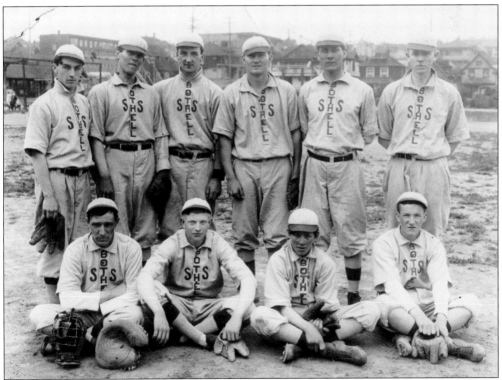

This June 28, 1913, photograph shows the Bothell Methodist Episcopal Church baseball team. Pictured are, from left to right, (first row) Robert Moyer (catcher and second base), Claude Dutton (left field), Guy Stickney (substitute), and Fred Beardslee (pitcher); (second row) Ross Worley (manager, third base, and pitcher), Allen Stickney (second base), Floyd Beardslee (center field), Frank Kinney (first base and captain), Glen Bailey (right field and pitcher), and Merritt Martin (shortstop and first base).

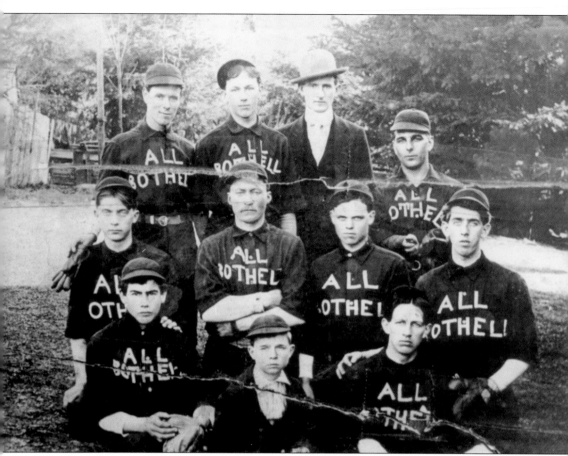

This photograph of the Bothell All-Stars baseball team is undated but was taken before 1907. Pictured are, from left to right (first row) Hildreth "Dutch" Ludington, ? McKay (mascot), and George Bothell (pitcher); (second row) Leslie Morton (first base), ? Smith, Jim Turple (third base), and ? Finerson; (third row) Jack Burns (second base), Vic Chambers (manager), Jim Wallace, and ? Dennis. The Bothell All-Stars suffered a tragedy on May 5, 1907, when Morton was hit in the head by a pitched ball. He sat out the remainder of the game, then went home and fell asleep. His mother was not able to wake him, and he died on the way to the hospital in Seattle. This accident led to a halt of baseball games in Bothell for a number of years.

Before becoming a doctor, Reuben Chase enlisted in Company A, 7th Vermont Volunteers at age 15. He mustered out as a corporal at Brownsville, Texas, in 1866. Chase began practicing medicine in 1871 under the old rules of medicine. When a law was passed requiring a diploma from a medical college, Dr. Chase entered medical school in 1877 and received his diploma in 1879.

This photograph shows Dr. Reuben Chase's hospital in the Stringtown area of Bothell. This area was on the road to Woodinville by way of the Pioneer Cemetery. The people in the photograph are Dr. Chase (right); his wife, Alice M. Ervay; and their children Helen, Lewis, and Ervay. The cost for a local call was $1.50 for a visit and medicine.

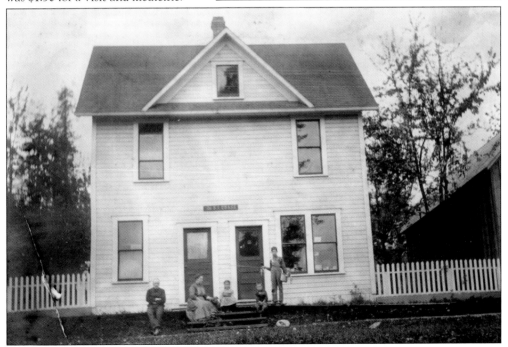

Dr. Reuben Chase made calls as far away as Edmonds—a 15-mile ride from his home and office in Stringtown—on this horse. The charge for such a visit was $5 including medicine. Other charges were as follows: $10 for obstetric care (with $1 for additional visits) and $5 to $10 for bone-setting.

Dr. Reuben Chase settled in Bothell because the town did not have a doctor and was in the midst of a typhoid epidemic. He treated over 40 cases of typhoid and only lost one patient: Oliver Davenport. Davenport is the man on the left in this photograph, which was taken at the Davenport farm in Stringtown before 1889.

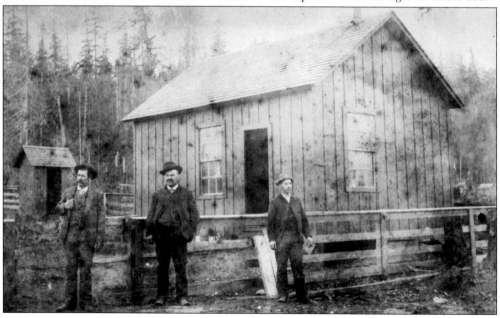

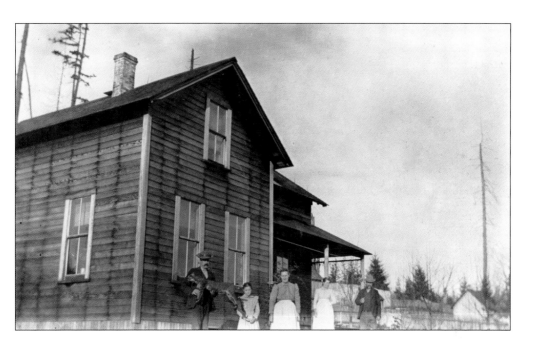

These two photographs, taken sometime after 1890, show Dr. Reuben Chase's Stringtown house (above) and the Stringtown settlement (below). Stringtown was given that name because of the row of houses built along the road near the bridge to Woodinville. The Davenport, Ervay, and Fish families were some of the early settlers of Stringtown. The photograph above shows a group of unidentified people with a man holding a cougar that had obviously been killed near the house. The Stringtown area is now part of the University of Washington Bothell campus. Dr. Chase's house is still standing and can be seen on the grounds. The City of Bothell worked with the university to ensure that this historic home was preserved. Dr. Chase, never in good health, died in 1908 and is buried in the Bothell Pioneer Cemetery.

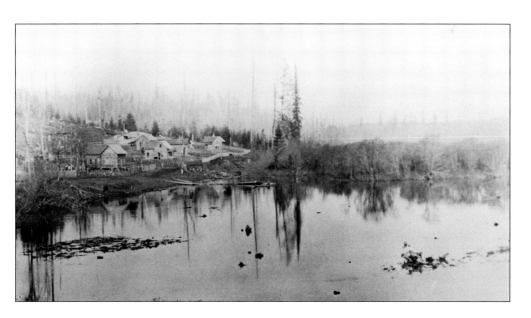

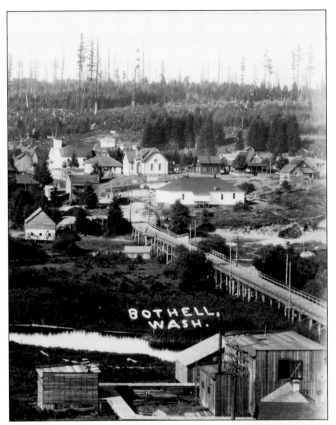

Two churches—the Norwegian Lutheran church and the Methodist church—and the band hall are visible in this 1910 photograph taken from Norway Hill. To the right are Eugene Dutton's home and the house that William Hannan built for his bride, Mima Campbell. The large white building just below the Methodist church is the band hall, which was built by the band members. It is apparent that this photograph was taken in 1910, because the sign on the building at far left is an advertisement for Buffalo Bill's Wild West show, which was touring the Northwest during the fall of 1910. The close-up below shows the sign on the barn. The railroad tracks were across the river, and the sign would be visible to train passengers traveling to and from Seattle.

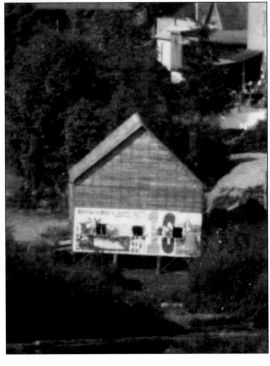

Three

GROWING PAINS

In 1908, real estate promoter S.F. Woody and Bill Guernsey, the new *Sentinel* editor, campaigned for incorporation. With incorporation, Bothell would be able to issue licenses and collect fees to be used to improve the town. Liquor licenses brought in the most amount of money, so a faction against the sale of liquor was naturally opposed to incorporation. The vote in April 1909 was 79 in favor and 70 opposed. George Sickles, the new city clerk, resigned his position soon after his appointment when he was asked to sign a liquor license.

At the start of the 20th century, Bothell was growing—several more businesses opened, and the specter of competition among similar enterprises started to be noticed in the community. Added to this was the division caused by the incorporation issue. Those who were not wholeheartedly supportive of incorporation were thought to be against growth in Bothell. They were ridiculed in the newspapers and called "Mossbackers," whose characteristics, according to Guernsey, were "Greed, Grouch, and Gall . . . The direct antithesis of public spirit and civic pride."

Seattle was preparing for the Alaska-Yukon-Pacific Exposition (A-Y-P), which was set to open in the summer of 1909, and this seemed like an excellent opportunity to showcase Bothell. The local Norwegians—Gerhard Ericksen, Jacob Mohn, and Albert Ness—contributed money and led a project to build a Viking ship replica in Bothell. The ship was piloted down the Sammamish River to Lake Washington for arrival at the A-Y-P for Norway Day on August 30, 1909.

The *Sentinel* ran a contest to find the prettiest girl in Bothell. Coupons for voting were available with each issue, and folks could vote many times. Ethel Penny, a very beautiful young lady, won the prize of an all-expenses paid trip to the A-Y-P.

Bothell had been accessible only by boat or train, and citizens were impatient to have an easier way for travel to and from Seattle. One man, Frederic Mills, attempted to build a flying machine in a field in Bothell with hopes to provide a quicker means of travel. After his craft crashed during its first test flight, he moved to Tacoma and then Portland to try again. The state of roads and the ability to connect to Seattle was on the minds of the citizens, and in 1913 the final road linking Bothell to Seattle through Lake Forest Park was celebrated by all.

After only one year, Guernsey left town and the *Sentinel* without any explanation. Woody was successful in his real estate business and served as the mayor of Bothell from 1913 to 1915. He left the city in 1916 and continued his real estate ventures in Seattle, Los Angeles, and San Diego, where he died in 1931.

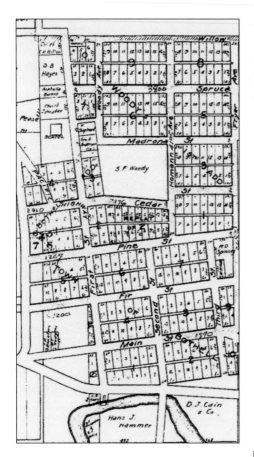

The street names in the downtown Bothell area have been changed from their original names, but the historic names are listed on the street signs today. Main Street has not been renamed, but Fir, Pine, and Cedar are now NE 183rd, NE 185th, and NE 186th Streets, respectively. First, Second, and Third Streets are now 101st, 102nd, and 103rd Avenues NE, respectively.

This early Bothell homestead map shows the city boundaries for the newly incorporated Town of Bothell. The area of incorporation was two-thirds of a square mile, or about 427 acres. Those who lived in the areas outside the boundaries still considered themselves part of the community.

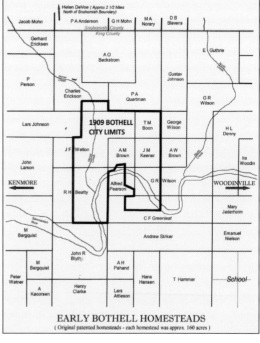

EARLY BOTHELL HOMESTEADS
(Original patented homesteads - each homestead was approx. 160 acres)

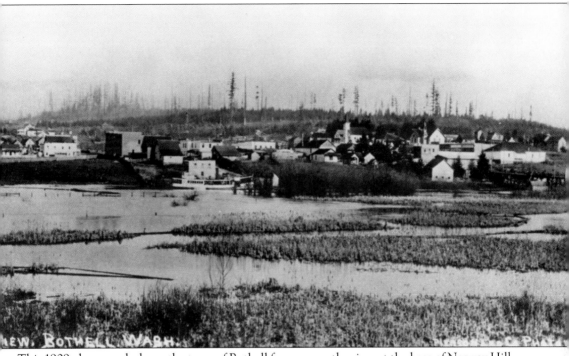

This 1909 photograph shows the town of Bothell from across the river at the base of Norway Hill. One can see just how difficult it could be to navigate the Sammamish River and why the Native Americans who lived along the river were called the Meanderer Dwellers. The steamer *City of Bothell* is visible at the First Street wharf. This is where passengers and freight were loaded and unloaded in the downtown area. At this time, there was no road connecting Bothell to Seattle, so the only way to get to Bothell was by boat or by train. Eventually, a short redbrick road built between Lake Forest Park and Bothell linked the town to Seattle.

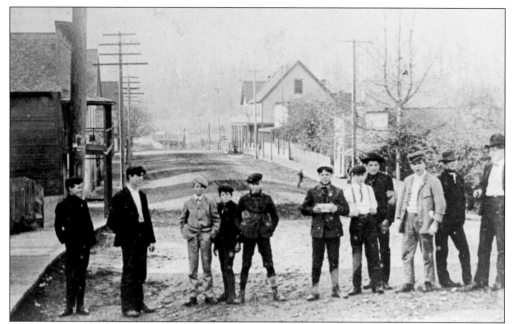

This 1906 photograph of Main Street with a view looking west shows several local boys. They are, from left to right, George Ericksen, Roy Oliver, Earnest Nelson, Arvid Pearson, Victor Nelson, Burton Hitsman, unidentified, Earnest Seaton, LeRoy Hitsman, Frank Renchy, and unidentified. The tall building in the center right is the Ericksen General Merchandise store (with the family's living quarters above it).

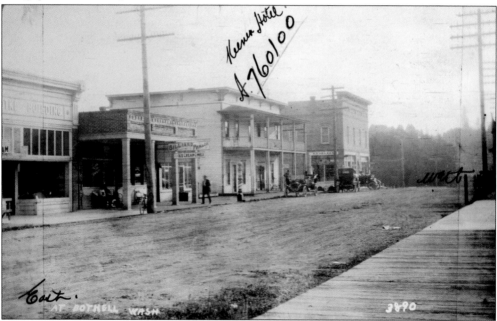

This is another view of Main Street looking west. This photograph shows the American Hotel on the corner of First and Main Streets. The next building is the Hannan Block (building). William A. Hannan operated a store on the main floor and rented out space on the top floor. This is the building where dentist Emma Beddow and optician Nellie Beddow had their offices.

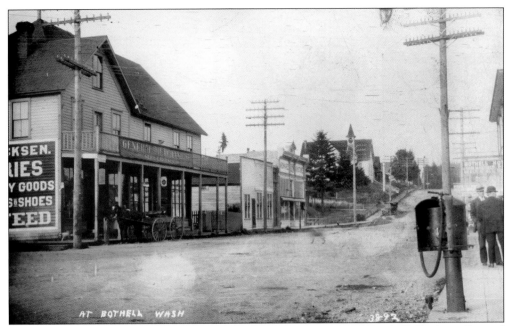

This photograph shows Main Street shortly after the incorporation of Bothell. Ericksen General Merchandise store is at the corner of First and Main Streets; Severence Bakery and Jacob Mohn's Hardware and Furniture are visible east of Ericksen's. Dr. Elmer Lytle's house (next to Mohn's Hardware and Furniture) is not completely visible, but the tree in the picture is Bothell's living Christmas tree that is still decorated during the Christmas season to this day.

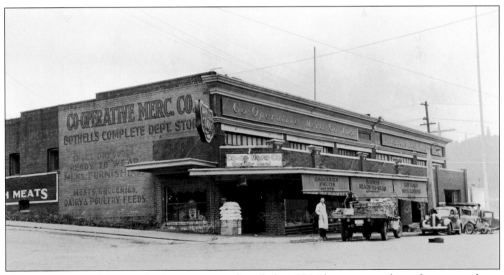

The Cooperative Mercantile Company was founded in 1906 by a group of merchants, teachers, and farmers. The enterprise was so successful that in 1908, it was able to build this durable brick building on the southeast corner of Second and Main Streets. The advertising for this store included the phrase "to serve the public, not fleece it."

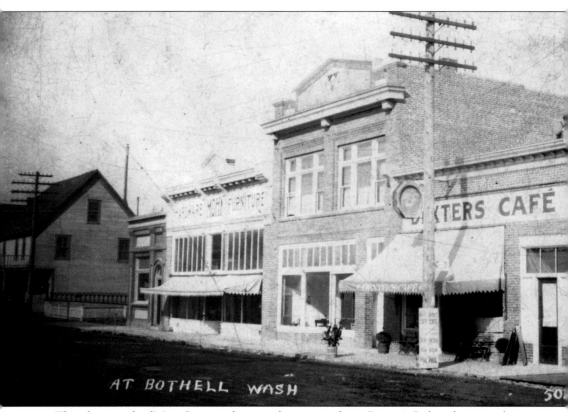

AT BOTHELL WASH

This photograph of Main Street with a view facing west shows Dexter's Café with a sign advertising "Fish, Oysters, and Pool." The next spaces are the Knights of the Maccabees and Knights of Pythias brick building, Mohn Hardware and Furniture, Bothell State Bank, an empty lot, and Ericksen's General Merchandise. Bob Dexter, who operated the café on Main Street, built the Blue Swallow Inn outside the Bothell city limits around 1918. It was probably built outside the city limits for good reason; the Blue Swallow Inn was a roadhouse where patrons could get liquor by the drink during Prohibition. Many roadhouses also had rooms to rent by the hour, but there is no evidence of that kind of activity in Dexter's venture. The Blue Swallow Inn property has had several owners, and the original building is long gone. The location is now home to Yakima Fruit Market.

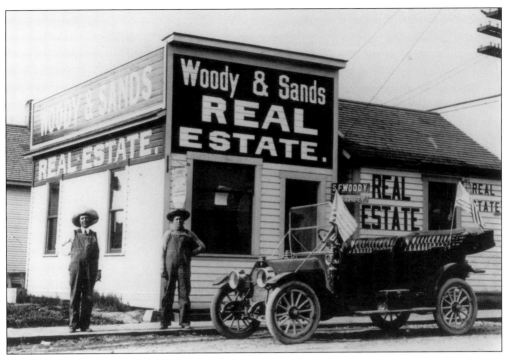

S.F. Woody (left) is standing in front of his real estate office with his partner, a Mr. Sands. Woody was the first land promoter in Bothell and also served as mayor. He was one of the proponents of incorporation and, along with the editor of the *Bothell Sentinel*, encouraged citizens to vote to make Bothell a city. Woody had other partners, but he eventually maintained his business as a sole proprietor. He married Isabel Fryer and brought his mother-in-law, Anna Fryer, to Bothell. He created a neighborhood north of Main Street called Woody's First Addition and registered the plat under his mother-in-law's name. Fryer Street and Woody Avenue show up on some old Bothell maps. Ethel Penny's father, Ira, built homes for Woody in Woody's First Addition.

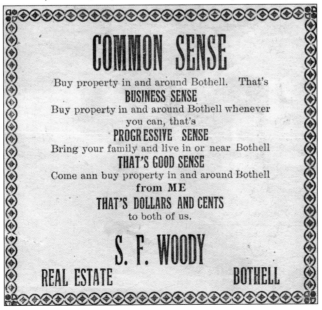

COMMON SENSE

Buy property in and around Bothell. That's

BUSINESS SENSE

Buy property in and around Bothell whenever you can, that's

PROGRESSIVE SENSE

Bring your family and live in or near Bothell

THAT'S GOOD SENSE

Come ann buy property in and around Bothell

from ME

THAT'S DOLLARS AND CENTS

to both of us.

S. F. WOODY

REAL ESTATE BOTHELL

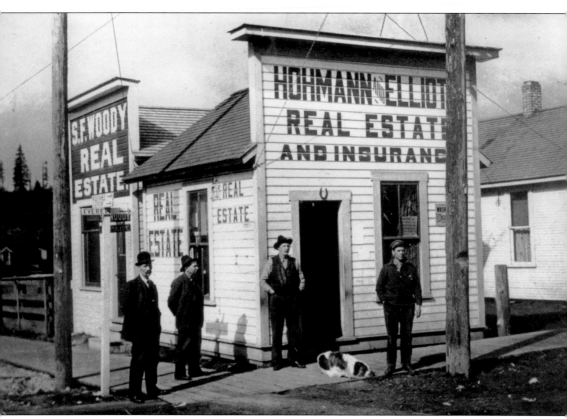

This photograph was taken sometime after 1908 at the northwest corner of First and Main Streets. There are two signs pointing toward Everett—one heading north and the other east. There were two ways to get to Everett: by traveling north on the Pacific Highway (Bothell-Everett Road) or east on the Sunset Highway (Route 522 toward Woodinville) and then north at Grace on what would become State Highway 9. The men standing in front are, from left to right, Bill Shepherd, George Bothell, Charles Hohmann, and Albert Ness. Hohmann, father of Vincent Hohmann, was one of the men who drove out to Wayne to pick up the dead and wounded after the Harry Tracy gunfight. Hohmann lived in Woody's First Addition, and the street that became 103rd Street was originally named Hohmann Avenue.

BotHELL CORRECTION PLa.
OF TOWN O
B-4 L-7
9
2-26-5

Dr. Elmer Lytle's house and office was on the northwest corner of Main and Second Streets where the Cain and Lytle cookhouse had been. Elmer Elsworth Lytle practiced medicine in Everett and Edmonds for six years and came to Bothell in 1896. At first, he worked with D.J. Cain in the shingle mill and grocery business, then, when the mill burned in 1905, he returned to medicine. Dr. Lytle was married three times. His first two wives died, and he married Marguerite Johnson, 30 years his junior, in 1912. The photograph at right shows the Lytle family; they are, from left to right, Marguerite, Elmer Jr., Elmer Sr., and Mary Anabel. Dr. Lytle died in 1931. In 1975, this house was moved to the Park at Bothell Landing, where it is now used as a community center.

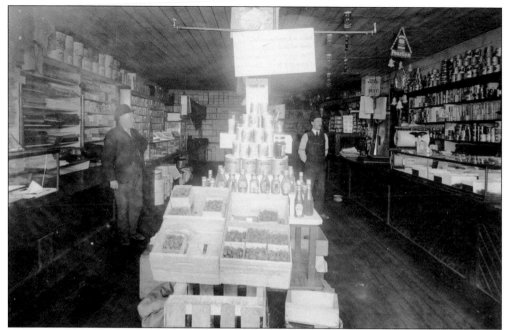

This is an interior photograph of the Hannan store in the early 1900s. At left is W.A. Hannan, and on the right is his clerk, Charles Wilson. Groceries and meat are stocked on the right; dry goods, on the left. A display of Heinz products is visible in the middle of the photograph with a sign above them stating the Heinz return policy.

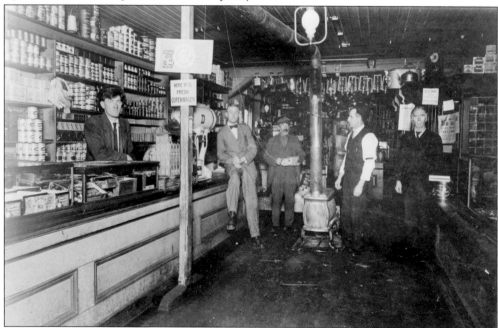

This is an interior photograph of Ericksen General Merchandise taken sometime after the incorporation of Bothell. From left to right are Lars Eidbo (a cousin of the Ericksens), George Ericksen, Lars Eyde, Doctor Victor, and a Mr. Estabrook. Canned goods are displayed on the left wall, and tobacco is in the case just below Eidbo. The post office is visible at right.

These two advertisements appeared weekly in the *Sentinel* beginning in 1908. Dr. Emma Beddow was the town's dentist, and her sister, Nellie Beddow, was the town's optician. Their practices were housed in the Hannan Building. Emma and Nellie were popular in the town, were included in town social events, and hosted parties for the community. Emma was an accomplished pianist who played for the first Bothell High School graduation and the first wedding in the Norwegian Lutheran church. The sisters came from England and lived with their parents in North Seattle.

It seems as if this advertisement from a 1909 *Sentinel* was a direct slam at Scandinavian merchants Gerhard Ericksen and Jacob Mohn. A ditty from this time was remembered by Carlton Ericksen, Gerhard's son, as: "Jake the jerk, it won't work; Woody runs the town." Ericksen also remembered that the Progressives believed the Scandinavians were opposed to incorporation and used ridicule and name-calling in their drive to see Bothell incorporated.

TIS SAD, SAD, ONLY TOO SAD! TIS SAD, SAD, ONLY TOO SAD! TIS SAD, SAD, ONLY TOO SAD!

EFEAT MOSSBACKISM

TIS SAD, SAD, ONLY TOO SAD! TIS SAD, SAD, ONLY TOO SAD! TIS SAD, SAD, ONLY TOO SAD!

We are ALIVE! ALIVE! ALIVE!

"Mossbackism" was the term Bill Guernsey and S.F. Woody used to characterize some of the Bothell pioneers and others who were not excited about incorporation. The newspaper published the names of those who were endorsed by the editor and asked the citizens to vote the straight ticket.

CITY OF BOTHELL INCORPORATED NOW

Hold ...

PROGRESS PROFICIENCY PROSPERITY PREVAIL PREPON-
DERATINGLY OVER PRUDISH PREPOSTEROUS
PETTY PREDATORY POLITICAL PROJECTS

MAJORITY TRIUMPH AT THE POLLS

BETTER STREETS, BETTER SIDEWALKS, BETTER BUSINESS, BETTER BOTHELL

Bill Guernsey does not hide his elation when reporting the incorporation election results. The vote for incorporation was 79 to 70. The "straight ticket" candidates—W.A. Hannan, J.H. Fitzgerald, G.A. Anderson, A.F. Bothell, and S.R. Reder (for treasurer)—all beat their opponents to become the first city officials.

Ethel Penny (right) grew up in Bothell on Pine Street in a house built by her father, Civil War veteran Ira Penny, who also built houses for S.F. Woody. She was named "the prettiest girl in Bothell" in a contest run by the *Bothell Sentinel*. Her prize was an all-expenses paid weeklong excursion at the Alaska-Yukon-Pacific Exposition in Seattle in the summer of 1909. She married Judge Askren, a widower, and served as the Bothell town clerk for many years. The clipping from the front page of the April 17, 1909, *Bothell Sentinel* shows the status of the contest.

That Beauty Contest

• •

Miss Julia Beckstrom	-	-	1793
„ Della Chambers	-	-	1912
„ Ethel Penny	-	-	1976
„ Mary Hollingsworth	-	-	1832
„ Innie Snudden	-	-	1443
„ Bertha Dutton	-	-	1384
„ Lousie Rebhahn	-	-	861
„ Mable Adams	-	-	78

SEE PAGE 2.

ONLY TWO WEEKS MORE

WATCH IT WATCH IT WATCH IT WATCH IT WATCH IT WATCH

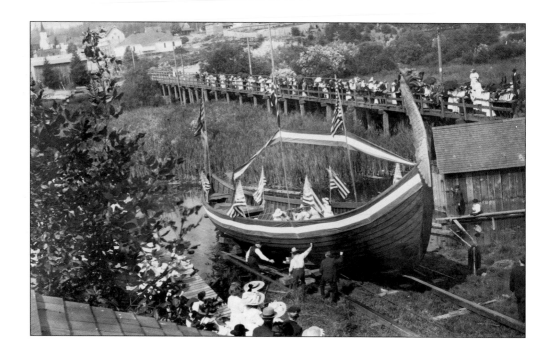

These two 1909 photographs show the launching of the Viking ship replica built in Bothell for Norway Day at the Alaska-Pacific-Yukon Exposition. The above photograph shows the Second Street Bridge lined with spectators as the boat is slid into the Sammamish River. The below photograph, with a view looking south toward Norway Hill, shows the boat as it floats in the Sammamish. The boat left Bothell, was piloted up the Sammamish to Lake Washington, and then headed to Kirkland to be sailed across the lake to the exposition grounds. The Viking ship was sold to Norwegian Americans in San Francisco for participation in the Panama-Pacific International Exposition Norway Day in 1915.

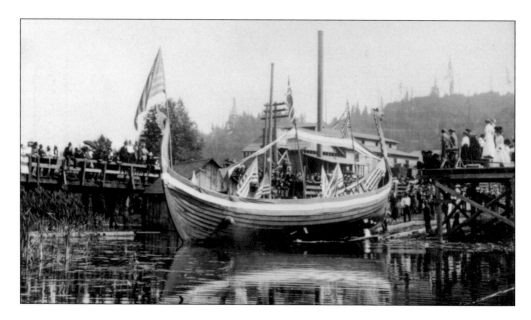

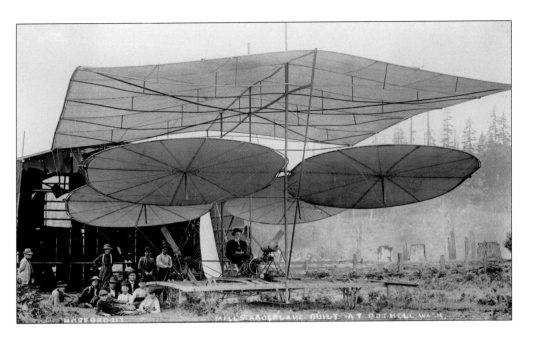

The Wright brothers' successful flight on December 17, 1903, encouraged amateurs and professionals all around the world to build machines that could fly. The above photograph of Frederic Rosenfield Mills's endeavor shows the kitelike design of his aircraft. The below photograph was taken after the first test flight when a gust of wind upended the craft before it got off the ground. Mills was a former circus balloonist who moved to Bothell in 1910 and used a downtown field owned by the Ericksens to build his aircraft. He was dubbed Bothell's "bird man" in the 1910 *Sentinel*. His father, Capt. L.E. Mills, lived with the family, and it is likely he is the well-dressed, bearded gentleman seen in both photographs.

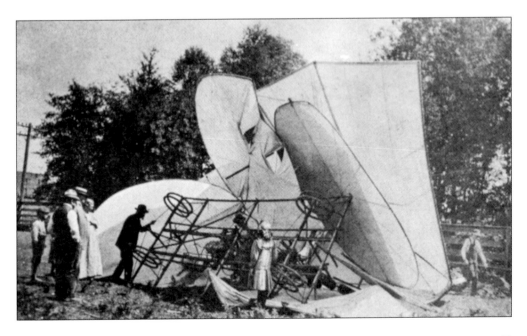

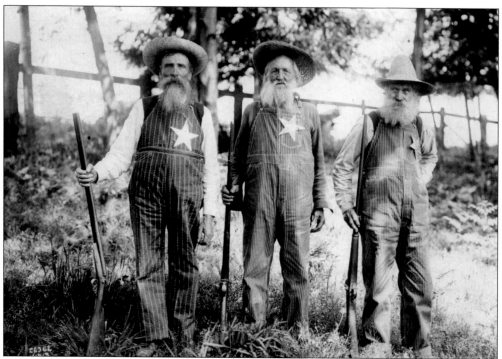

In 1913, Bothell celebrated the completion of the redbrick road between Lake Forest Park and Bothell that effectively connected Bothell to Seattle. Bothell hosted "Good Roads Day" with a visit from Washington's governor, Ernest Lister. The whole town was involved in the festivities. In the above photograph are P.J. Quartman (left), Columbus Greenleaf (center), and Andrew Beckstrom. In the below photograph, Mayor S.F. Woody has just presented the key to the city to Governor Lister, who is holding the key. Gladys Hannan (holding a hoe) is visible at far right.

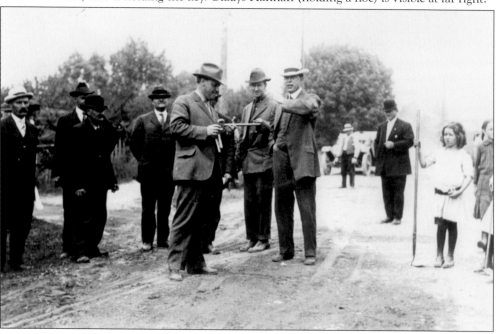

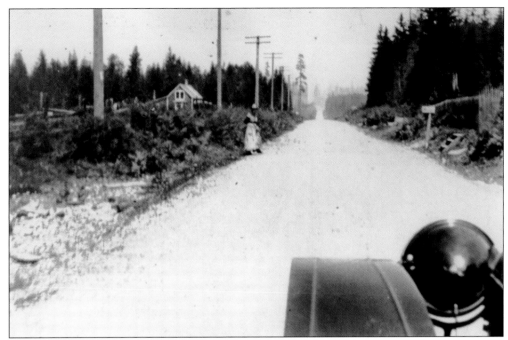

On Good Roads Day, celebrated on May 29, 1913, a parade of vehicles carrying the governor and other dignitaries traveled on the Pacific Highway (first called the Everett Trail and now known as the Bothell-Everett Highway) from the Canadian border to Olympia. This is a view from south Everett looking toward Silver Lake.

On Good Roads Day, a parade of automobiles is shown heading east on Main Street between First and Second Streets. The building on the left near the banner is the Hannan Building. The building to its left is the Bothell Hotel. Westhill is in the background.

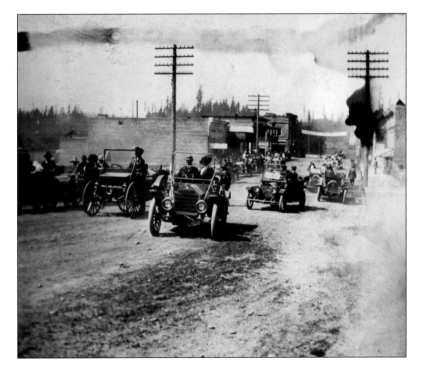

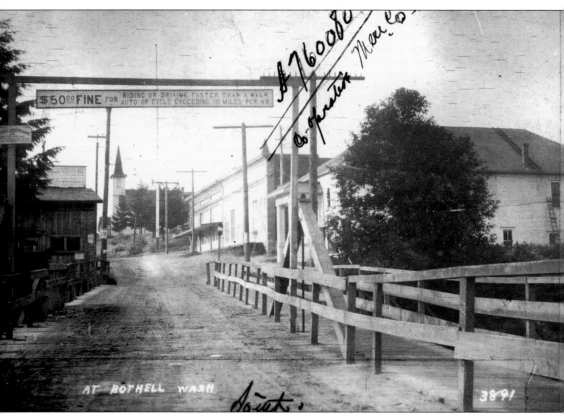

$50.00 FINE FOR RIDING OR DRIVING FASTER THAN A WALK AUTO OR CYCLE EXCEEDING 10 MILES PER HR.

AT BOTHELL WASH

3891

As a city council member, S.F. Woody advocated for a speed limit in the town of Bothell—even though he said he would probably be the first one cited for speeding. In 1912, just before he was elected mayor, Woody was caught speeding across the Second Street Bridge, and he was indeed the first person to be cited for speeding in the city of Bothell. He chose to fight the charge in court, and the trial was reported in the *Bothell Sentinel*. He was his own representative, called witnesses, and got the charges dismissed because the town had no instrument to measure speed. According to the sign, the speed limit is "10 MPH."

S.F. Woody continued to advocate for good roads, and these 1915 photographs show him apparently filling in potholes with his shovel. These publicity shots are probably related to a January 30, 1915, article in the *Sentinel* entitled "Good Roads." The article is a collection of adages about the value of good roads. Here are a few of the 11 listed: "The growth of any community is dependent upon good roads," "Happiness, contentment and prosperity don't go with bad roads," "Mud holes are civilization's greatest parasites. Abolish them." Now that a road connected Bothell to Kenmore and Seattle, the area was becoming a suburb, and "good roads" would eventually draw people to the city.

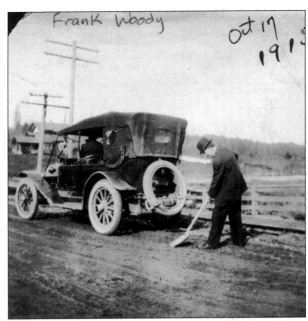

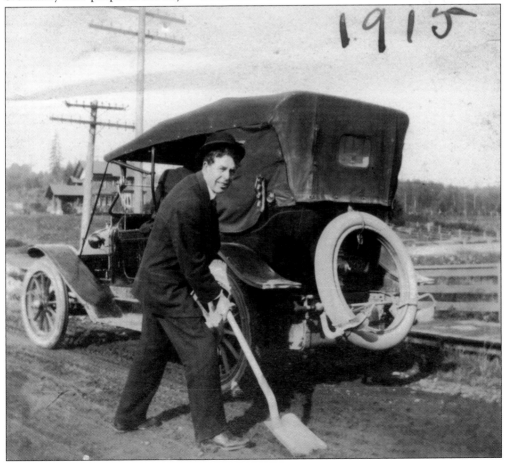

S.F. Woody's 1915 campaign for good roads shows him pointing out a chuckhole in the street. Shortly after this, he left Bothell and moved to Seattle. After a time in Seattle, he moved to Los Angeles, then to Pacific Beach near San Diego. He was involved in real estate development in those cities (as he was in Bothell). At the time of his death, Woody was a well-respected businessman in the Pacific Beach community and recognized as a leader in the growth and development of that little city. When his death was reported in the *Bothell Sentinel* on September 12, 1931, it was said that the name "Woody" was a household word and that it was Sidney F. Woody who gave the town its second start on its road to modernity. Some of the old-timers remember him as the first real promoter of the city.

Four

FOURTH OF JULY

The Fourth of July has been observed in Bothell every year since 1886—and continues to be to this day. It was an all-day affair with a parade that started across the Second Street Bridge on the Norway Hill side and headed down Main Street. Floats representing businesses, churches, and fraternal organizations made up a large part of the parade. After the parade, picnics and competitions were the order of the day. The Fat Men's Race, Fat Women's Race, Pie Contest, Log Rolling, and the Greased Pole and Pig were some of the annual contests featuring prizes to be won.

The 1910 "Comic Parade" theme, as reported by the *Bothell Sentinel*, is worthy of focus, since photographs of the Bothell Concert Band and Claude Dutton show them in blackface. In the July 9, 1910, edition of the *Bothell Sentinel*, a reporting of the day's activities gives some context to this unusual event. In 1910, Jack Johnson, the first African American heavyweight boxing champion, was scheduled to fight James Jeffries, a white man, in Reno, Nevada. The parade theme—as well as other activities of that day—focused on this event. A crowd gathered around Rupp's drugstore for round-by-round updates on the fight. These updates were provided either by telegraph or telephone, since radio was not available in 1910. Johnson knocked out Jeffries in the 15th round.

Throughout the years, many of the contests lost popularity and were replaced with other activities. In the 1970s, Westhill resident Dave Harkonen suggested that Bothell stage a reenactment of the Battle of Lexington and Concord as part of the annual Fourth of July Festival. He and his wife had visited that historic site and were struck at how the arched North Bridge resembled the bridge in the Park at Bothell Landing. The resulting reenactment was a popular activity for many years and was followed by a patriotic concert in the park's amphitheater.

Throughout the years, Bothell's Fourth of July celebration has grown in popularity. Weeks before the holiday, hundreds of chairs line the parade route for those who want to be sure to have a prime spot.

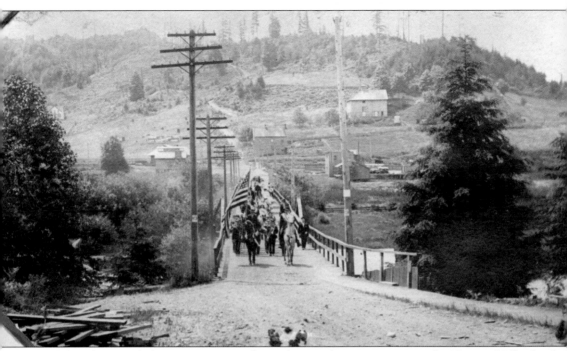

This photograph from 1907 or 1908 shows the parade commencing on the Norway Hill side of the Second Street Bridge heading toward the town. Dignitaries on horseback lead the parade, followed by the Bothell Cornet Band. Floats from town businesses, lodges, and churches follow the band. Other communities, such as Woodinville, brought floats to be included. The structures visible are, from left to right, the railroad depot, Will Chambers's house, and Alfred Pearson's barn. Below the barn is Krause's Saloon. It is also possible to see the rough road winding up to the top of Norway Hill, where several homesteads and farms and orchards were established.

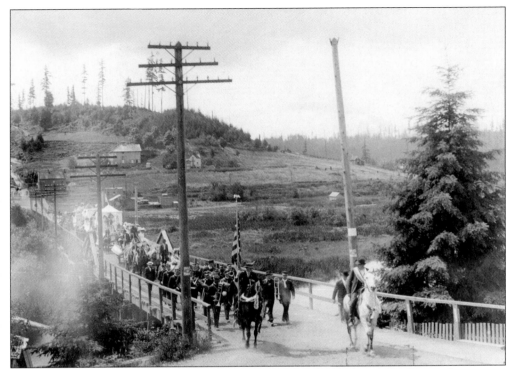

This photograph shows the 1907 or 1908 parade from a slightly different angle than in the previous photograph. Alfred Pearson's house is visible just left of the center of the scene. This house was built in 1884 using materials exclusively found on the property. Pearson started the Spring Hill Water Company. Spring Hill was another name for Norway Hill, since it was saturated with water.

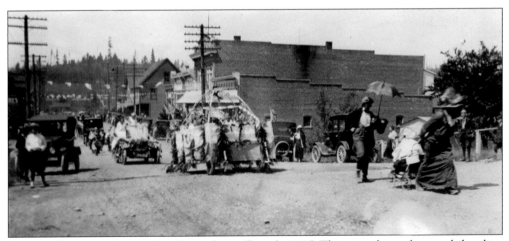

Decorated cars started to replace horse-drawn floats by 1915. This view shows the parade heading east on Main Street. The brick buildings on the right are Mohn's Hardware and Furniture and Dexter's Café. Ericksen's General Merchandise is the last building on the right. Westhill is visible in the distance.

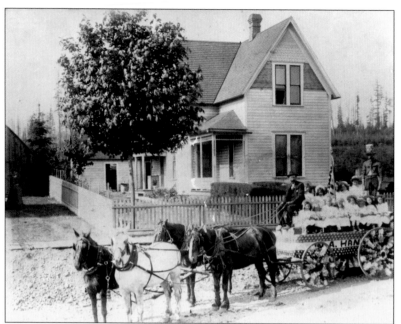

This photograph was taken in front of the William A. Hannan house on Main Street around 1906. Hannan's general store was just a short walk from this house. The children are unidentified, but the young girl sitting just below the driver is Gladys Hannan, who was well known for her bright red ringlets.

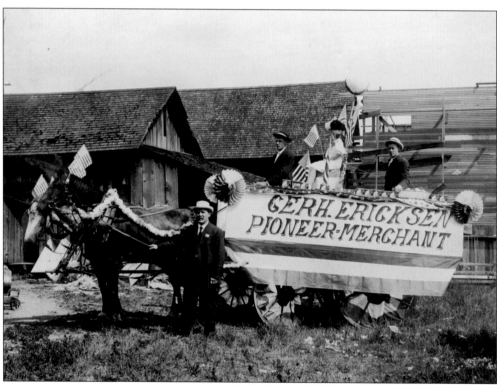

This 1908 float for Gerhard Ericksen's General Merchandise store shows his pride in being a "Pioneer Merchant." Gerhard is standing near the horse. Sitting on the float are, from left to right, Lars Eidbo; an unidentified girl; and Gerhard's son, George Ericksen. Eidbo, an Ericksen relative, worked in the store.

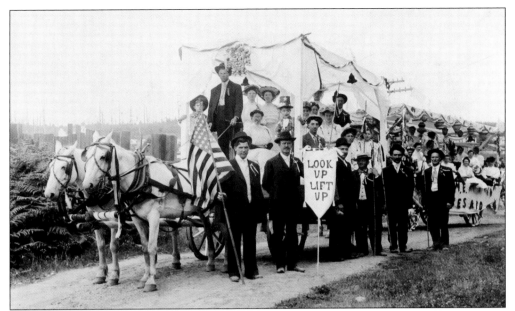

This 1908 Methodist church float has Howard Hosmer (driver) holding the reins. Seated to the right of him is Lena Bothell; standing to the right of him is Bertha Dutton. Clark Ross, who became Bertha's husband, is the man above the sign that reads, "Look Up Lift Up." This picture was taken in front of the Town Park, which is near today's Park at Bothell Landing.

This 1908 photograph shows the Methodist Ladies' Aid Society float followed by the Ericksen General Merchandise float. The Methodist Episcopal church was started in 1895, and many of Bothell's early settlers belonged to this church. By 1900, the Ladies' Aid Society was very active in the church and town.

This float represented the Maccabees lodge in the 1905 parade. The lodge was founded by members of the Foresters and originally named the Knights of the Maccabees. After the 1911 fire, the lodge built a brick structure on Main Street that is still standing. The Maccabees, along with the Odd Fellows, established the Bothell Pioneer Cemetery on land donated by George Wilson.

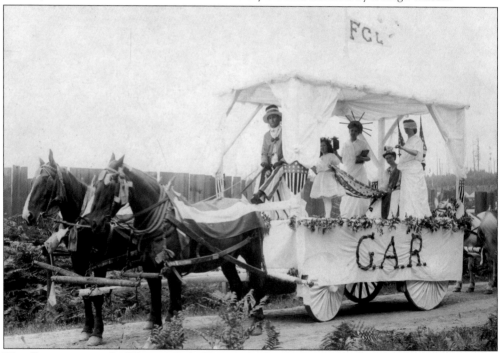

This float represents the Women's Relief Corps, the female arm of the Grand Army of the Republic (GAR), in the 1908 parade. From left to right on the float are unidentified (driver), Gladys Hannan, Hannah Staples (as Liberty), Alta Elliot, and a blindfolded Marie Campbell (as Justice).

The photograph at right shows Claude Dutton, age 15, in blackface riding his cow dressed in overalls for the 1910 "Comic Parade." He took third prize for this getup. Dutton was a member of the 1914 Bothell High School graduating class and served in World War I. The below photograph shows him in his World War I uniform. After the war, he settled in Bothell, was a master mechanic at Green Ford, served on the Bothell City Council, and served as fire chief for 15 years. He was an active member of the Bothell Historical Museum and volunteered for the Bothell Parks Department. Dutton died in 1989 at age 94 and is buried in the Bothell Pioneer Cemetery.

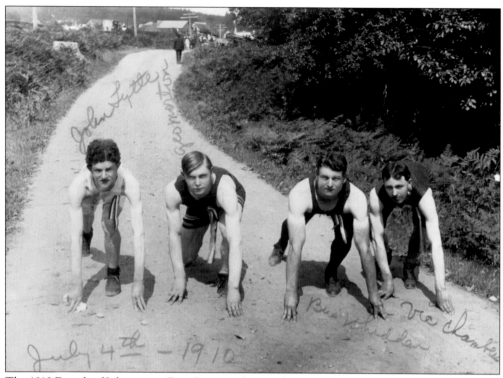

The 1910 Fourth of July race on First Street is about to begin. These boys are probably in the high school age group. The runners are, from left to right, John Lytle, George Morton, Bus Vohidden, and Vic Chambers.

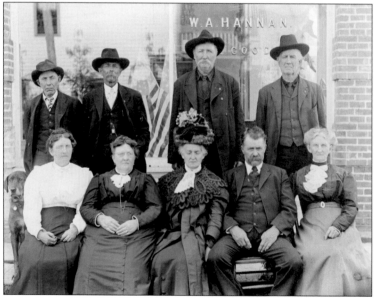

This group of pioneers sitting in front of the Hannan Store at First and Main Streets on July 4, 1910, represents Bothell's first families. Pictured are, from left to right, (first row) Rachael Bothell Keener, Clara Cover, Jane Johnson, John Keener, and Mary Ann "Dot" Campbell; (second row) Dave Bothell, Jake Cover, William Johnson, and Robert Campbell.

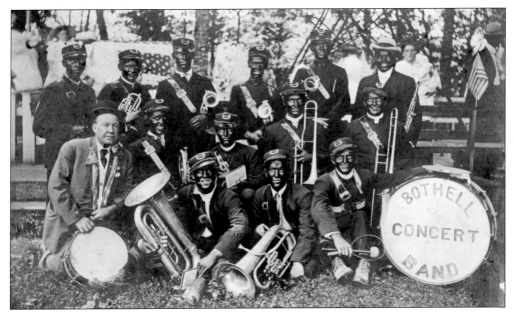

The Bothell Concert Band, formerly the Bothell Cornet Band, was part of the 1910 "Comic Parade" with "faces black as night," according to the July 9, 1910, edition of the *Bothell Sentinel*. This group took first prize for its performance. The band members are, from left to right (first row) James Brackett, Ray Stingley, Robert L. Denton, and Dave Staples; (second row) Carlton Ericksen, Carl Beckstrom, Ulrich Beckstrom, and Dan Hall; (third row) Forbes Chambers, Hanford Mohn, John Beckstrom, Jack Burns, unidentified, and Arnold Mohn.

Harlan Rupp stands in front of his drugstore. Rupp's drugstore was located in the Hannan Building at First and Main Streets, with the entrance facing First Street. On July 4, 1910, a crowd gathered in front of this store after the parade for updates on the heavyweight championship fight between Jack Johnson and James Jeffries, which had inspired some locals to wear blackface during the parade.

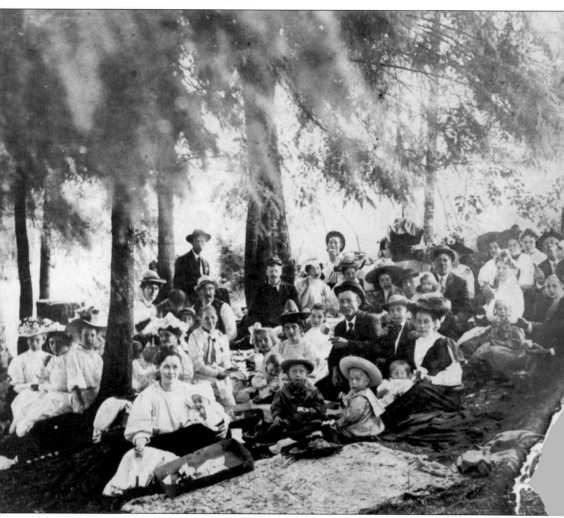

This 1905 Fourth of July picnic scene is assumed to be in the area of Blyth Park. The photograph was found in the papers of Elmer Carlberg, a Woodinville pioneer and amateur historian. Carlberg wrote for the *Bothell Citizen* in the 1950s in a fanciful and humorous style. Blyth Park was created on land purchased from Joseph Blyth by the Lions Club and donated to the city in 1959, so, although this photograph is labeled "Blyth Park," the land was not a park until after 1959. What Carlberg probably meant was that this picnic took place on the property owned by Christina Blyth (John Blyth died in 1901) in the general vicinity of where Blyth Park is today. That would be a beautiful picnic spot, as it is close to the river and in a nicely shaded bower.

This photograph shows two chairs positioned on Main Street between 102nd and 103rd Streets on February 15, 2015, with the message "Reserved for Parade July 4, 2015." Although this was a joke, the Bothell Fourth of July parade is so popular that every year hundreds of chairs are lined up along the parade route several weeks in advance of the event. (Author's collection.)

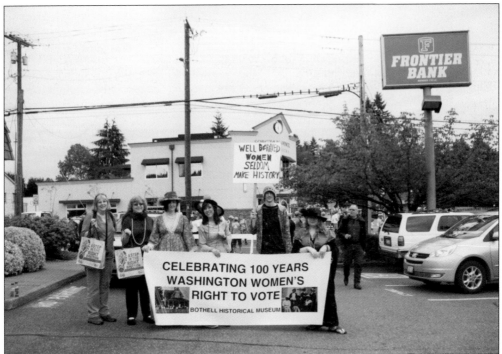

The 2010 parade had a group of women and one man marching to celebrate the 100-year anniversary of women earning the right to vote in Washington State. This photograph was taken just before the parade began. Mary Farley, a Bothell High School graduate and member of the Bothell Historical Museum, organized this effort. (Mary Farley.)

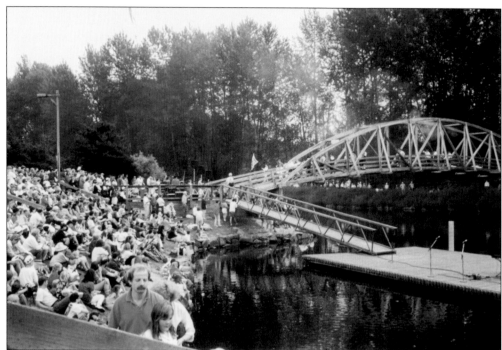

Bothell's Dave Harkonen visited Lexington and Concord, Massachusetts, in the 1980s and thought the North Bridge resembled the bridge at the Park at Bothell Landing. He spearheaded a drive to use the park as the location for a reenactment of the Battle of Lexington and Concord for Bothell's Fourth of July celebrations. Real Revolutionary War–style muskets were used, and people of all ages were invited to participate. Paul Revere galloped down the Sammamish River trail to announce the coming of the British, then the redcoats marched across the bridge and the battle began. The audience seated in the park's amphitheater watched the excitement from across the river. Reenactments started in the 1980s and continued into the mid-2000s, when construction at the park made it impossible for them to continue. (Both, Dave Harkonen.)

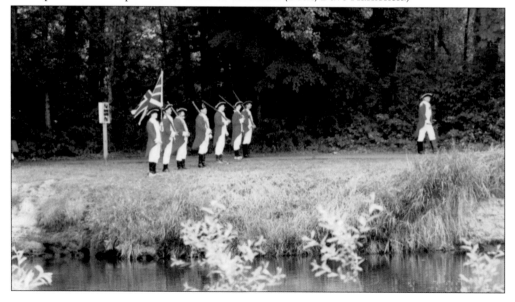

Five

ICONIC BOTHELL

The fire of July 2016 was a horrible event, but there were no casualties, and it showed the resiliency and community spirit in the town of Bothell. Whether it is to save the streams, clean up the river, provide open space and parks, or petition for safe walking areas for schoolchildren, Bothell citizens get involved, so it came as no surprise that the community raised nearly $100,000 for businesses that lost everything in the fire.

Walking around Bothell's Main Street today, visitors can see signs of a community that is just over 100 years old. The former Mills Music building was the Maccabees lodge. Hana Sushi is in the Bothell State Bank building. Alexa's Café is in the former George Dawson Cash Grocery building. The 3 Lions Pub is in a structure that has always been a tavern. Downtown Bothell will forever be the historic center of the community, and with revitalization, more of its history will be evident. The Bothell Library, Ranch Drive-In, Hillcrest Bakery, Worthington Licensing, Brooks Biddle, Yakima Fruit and Produce, and Country Village have all been in Bothell for at least 30 years and feel historical for many. McMenamins and Beardslee Public House are just two of the many newer establishments that also seem destined to become local landmarks.

All of the neighborhoods have their own stories to tell. Waynita is a combination of Wayne and Juanita. No one knows why the railroad stop was originally named Wayne, but it has stuck for over 100 years. Westhill has the beautiful Magnolia Dairy, the last piece of property saved under the King County Farmland Preservation Program in 1986. In 1909, North Creek was advertised as a place for city-weary Seattleites to establish farms in the bucolic valley. Today, instead of a giant cement shopping center, North Creek hosts high-tech companies yet retains open spaces for playfields, paths, and parks.

Bothell grew from a tiny wilderness settlement into a city of over 43,000 people spread out over 12 square miles, from three Protestant churches to over 40 houses of worship, and from 24 public school students to 22,000 attending four high schools.

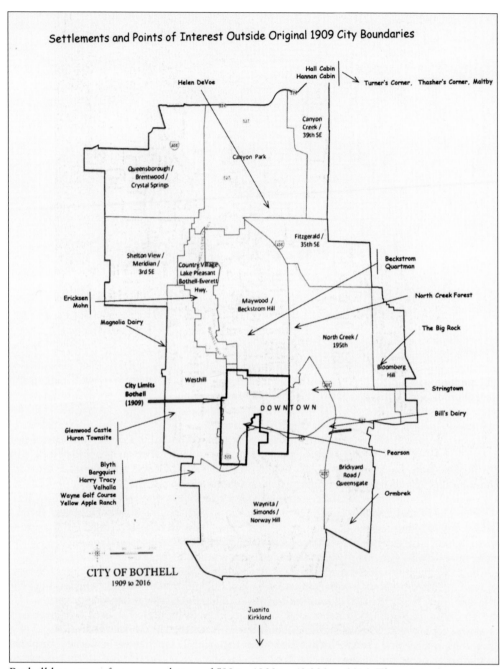

Settlements and Points of Interest Outside Original 1909 City Boundaries

Hall Cabin
Hannan Cabin

Turner's Corner, Thasher's Corner, Maltby

Helen DeVoe

Canyon
Creek /
39th SE

Canyon Park

Queensborough /
Brentwood /
Crystal Springs

Fitzgerald /
35th SE

Shelton View /
Meridian /
3rd SE

Country Village
Lake Pleasant
Bothell-Everett
Hwy.

Beckstrom
Quartman

Ericksen
Mohn

North Creek Forest

Magnolia Dairy

Maywood /
Beckstrom Hill

The Big Rock

North Creek /
195th

Westhill

Bloomberg
Hill

City Limits
Bothell
(1909)

DOWNTOWN

Stringtown

Bill's Dairy

Glenwood Castle
Huron Townsite

Pearson

Blyth
Bargquist
Harry Tracy
Valhalla
Wayne Golf Course
Yellow Apple Ranch

Brickyard
Road /
Queensgate

Ormbrek

Waynita /
Simonds /
Norway Hill

CITY OF BOTHELL
1909 to 2016

Juanita
Kirkland

Bothell has grown from a population of 599 in 1909 to 43,000 in 2016. The original area of the incorporated town was two-thirds of a square mile (about 430 acres). Today, Bothell covers more than 12 square miles (or 7,757 acres), spanning two counties—King and Snohomish. This map displays the Bothell of today and some of the local areas of interest.

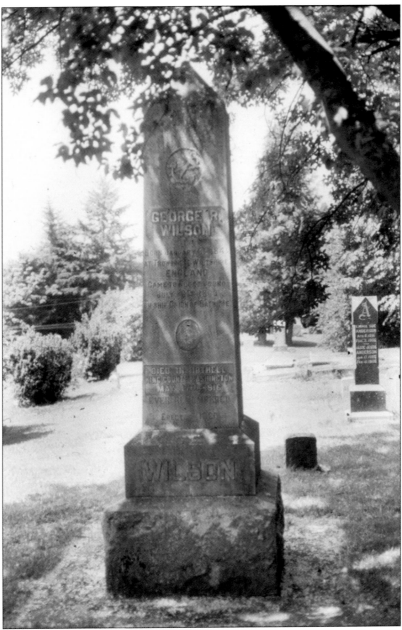

In 1889, Maybelle and Freddie Lufkin died while their family was staying in Bothell; since the town had no cemetery, George Wilson donated property so these children could have a proper burial. In 1909, five acres were added to the cemetery, which was situated outside the town limits on top of a hill with a spectacular view of the Sammamish River. The cemetery trustees transferred the title to the Odd Fellows and Maccabees for $1. Some of the pioneers buried in the cemetery include George R. Wilson (whose grave is pictured here), Mattias Bargquist, August Bartleson, John Blyth, David C. Bothell, Dr. Reuben Chase, Gerhard Ericksen, and William and Mima Hannan. The Swedish Lutheran church established a cemetery on the east side of Westhill. The cemetery, although in disrepair, still survives, and community volunteers led by Robert Beckstrom, a grandson of Andrew and Augusta Beckstrom, are working to restore it.

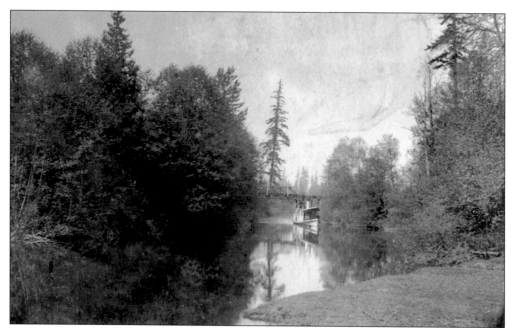

The 1907 photograph above shows the steamer *Acme* heading toward Bothell, having just passed under the railroad trestle built in 1887. This trestle and the connecting tracks were abandoned in the 1970s, and a portion of the old railroad bed is currently part of the Burke-Gilman and Sammamish River Trail systems. Children used the trestle as a diving platform for many years until Michael Schuerhoff of Mill Creek was pushed to his death late at night on January 2, 1996. He was with a group of teenagers who were subsequently tried for his murder. The trestle was modified to provide a bridge to Blyth Park, and a high wall was added to prevent access to the river. Schuerhoff's family and friends erected a memorial to him that still stands at the west entrance of the bridge.

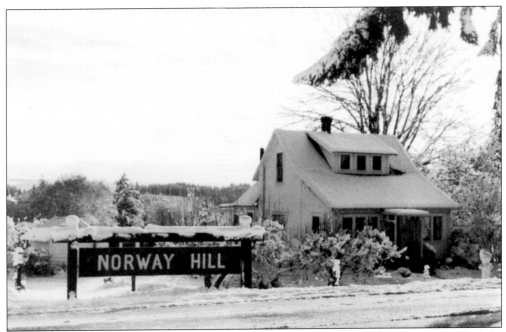

This photograph was taken sometime in the 1990s. The house to the right of the sign was built by Tonder Johnson in 1908. His daughter, Hulda Sutton, wrote of growing up in "wonderful Norway Hill." According to Clarence "Punky" Herman, Norway Hill provided woods, a cave, ponds, rope swings, and even a World War II lookout tower for kids to explore. (Barbara Ruiz.)

This 1945 photograph shows the house built in 1906 by master builder Jens Hansen. This property was on a 10-acre farm that included an orchard, and some of the fruit trees remain on the property today. In 1970, the Kienast family purchased the home on its two-acre lot. (Sue Kienast.)

The "Lazy Husband Act" went into effect on June 13, 1913, as a means to force men who deserted to provide for their families. Men who were caught ended up in a jail or stockade and were put to work on civic projects, and the money they earned was sent to their deserted families. From 1913 to 1915, Bothell had a stockade on property rented from a shingle mill near the river. The incarcerated men in Bothell were put to work constructing a road up the north side of Norway Hill. This road was known as "Lazy Husband Road" until the streets were given numbers in the late 1900s. In 1916, the stockade in Bothell was abandoned, and a new county work farm in the Willows area near Redmond took its place. In 2016, the Landmark Preservation Board brought back the original name and installed a new street sign. (Author's collection.)

In 1913, Bothell celebrated the completion of the four-mile highway that connected Bothell to Lake Forest Park with "Good Roads Day," because this road would mean a newfound mobility for Bothell residents. Greek and Italian immigrants built the road with bricks from Renton. Some of the Bothell pioneers tell of watching the workers and being entertained by the unfamiliar languages used by the bricklayers. The bricks were covered with asphalt when they proved to be too slippery in wet weather. A portion of the brick road was saved, and the Landmark Preservation Board—with the leadership of city planner Barbara Grace—created a small park adjacent to the Burke-Gilman Trail and Wayne Golf Course. Woodinville High School welding students, under the direction of teacher Jay Tonnelslan and led by student Riley Schroeder, added the Model T sculpture in 2015. (Author's collection.)

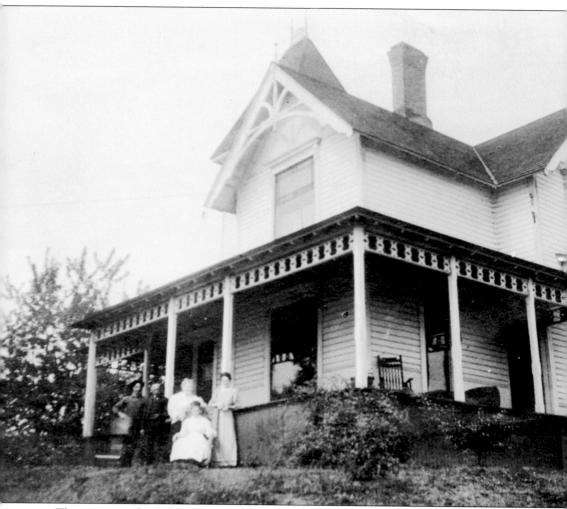

The superintendent of the Huron Mill, a Mr. Drew, had this home built in about 1894. Nothing much is known of Drew or how long he occupied the residence. William Hall bought the house in 1906. Hall's original home was a log cabin east of the Canyon Park area of Snohomish County. Hall moved his large family into this imposing residence on Westhill and called it Glenwood Castle. This home is still standing behind Brooks Biddle Auto dealership on Hall Road. Dan Hall, one of William's sons, played the trombone in the Bothell Cornet Band. Dan worked for the Ford dealership in 1915 and later worked as a bus driver for Bothell High School. His portrait can be seen at McMenamin's Hotel.

In 1931, Joe Blyth opened Wayne Golf Course on property he inherited from his parents, John and Christina Blyth. The clubhouse, pictured in this 2017 photograph, was said to be modern in every detail, according to the *Bothell Sentinel*. The original golf course had nine holes and offered cross-river shots with hills where flags cannot be seen, so judging distance was a challenge.

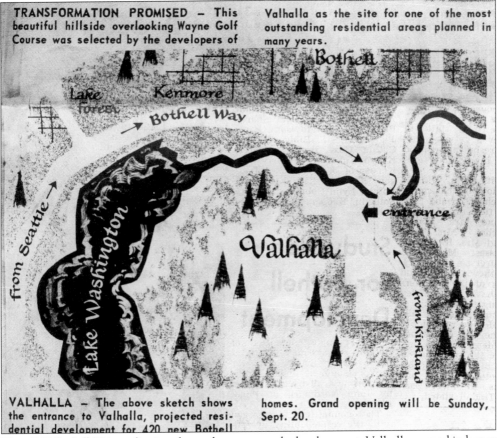

TRANSFORMATION PROMISED – This beautiful hillside overlooking Wayne Golf Course was selected by the developers of Valhalla as the site for one of the most outstanding residential areas planned in many years.

VALHALLA – The above sketch shows the entrance to Valhalla, projected residential development for 420 new Bothell homes. Grand opening will be Sunday, Sept. 20.

This 1959 *Bothell Citizen* clipping shows the new upscale development, Valhalla, named in honor of the Scandinavians who settled in the area. Part of this neighborhood sits on what was once Mattias Bargquist's property on the south side of the river. Ingemar Johanson, Swedish heavyweight world champion, was on hand for Valhalla's grand opening on September 27, 1959.

In 1921, George Dinsmore bought acreage in the Wayne area of Bothell and moved his family from Redmond, using their life savings to establish a truck farm. According to his daughter, Irene, who was interviewed in 1989, the Dinsmores grew "just about everything on the farm." In 1938, Dinsmore planted the apple trees shown here, choosing the Yellow Transparent variety because, according to Irene, "they were early apples, and he could beat the market." Nearly eight decades later, the trees still bear fruit. This property is currently part of the Wayne Golf Course back nine holes. Thanks to the work of the OneBothell organization, the City of Bothell, and the Forterra land conservation organization, this historic property—along with the entire Wayne Golf Course—will be preserved for future generations. (Author's collection.)

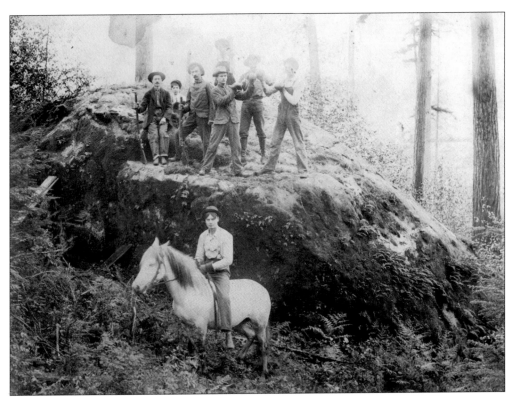

Across the North Creek valley on Bloomberg Hill stands a huge boulder left during the Ice Age. Bothell folks liked to pose for pictures with the giant rock. This photograph shows a group of Bothell boys with boxing gloves and rifles posing on what they called the "Big Rock." The Big Rock can be seen on the west side of NE 195th Street just above the Seattle Times Building.

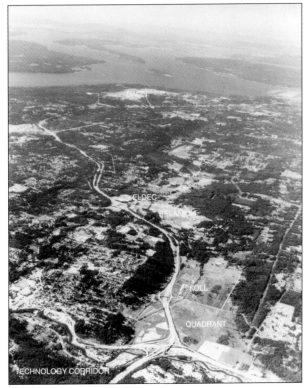

This 1984 aerial photograph shows the Technology Corridor that was built in the North Creek area. The view of the valley could have been seen from the "Big Rock" in the early days. The city and the developers created a well-loved center for business and recreational activities with playfields and walking/biking/running trails.

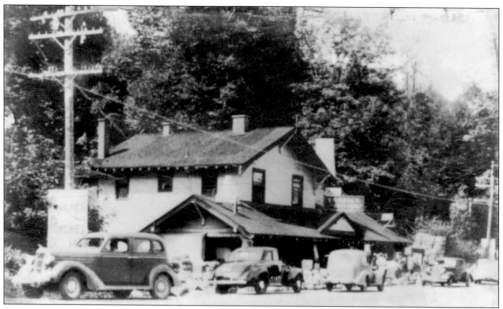

In 1916, Bob Dexter, owner of Dexter's Café, created the Blue Swallow Inn about a half mile west of town that operated during Prohibition. After Prohibition ended, Ken and Marie Lynch moved into the empty Blue Swallow Inn. Ken, a milk truck driver, started driving to the Yakima area to buy produce and bring it back to Seattle and Everett to sell. Marie also sold produce from the front porch of their home until 1950, when they tore down the house and built an open-air produce market. In 1971, Doug and Jane Poage purchased the market from the Lynches and operated it from 1971 until 1986. In 1986, Stuart and Karin Poage took over, and this family-run Bothell institution has now been in the Poage family for 46 years. (Both, Karin Poage.)

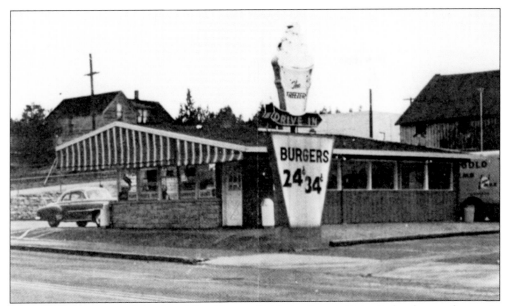

Across from Anderson School and Pop Keeney Field, the Ranch Drive-In has been a fixture in Bothell for over 60 years. It started as a Zesto's, part of a Seattle franchise, and became the Freezer and then the Ranch when Willard Austin bought it in the late 1950s. The restaurant is owned and operated by the third generation of the Austin family.

In 2015, McMenamins opened a destination resort hotel by remodeling the 1931 Anderson Junior High School and the Northshore Ruiz-Costie Pool. The complex has quickly become a gathering spot for the community. Renovations were done with a sense of history and a touch of whimsy. Bothell teachers, pioneers, and community leaders have been honored by having hotel rooms named after them. (City of Bothell.)

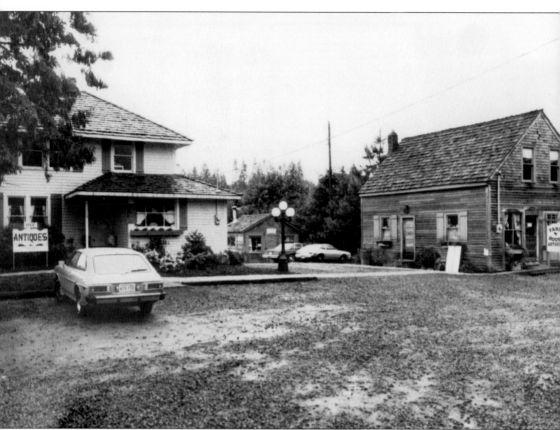

Country Village came into existence in the early 1980s, but it has a historical ambiance. The property was first settled by Gerhard Ericksen, and a two-story farmhouse from that era became Farmhouse Antiques, the first Country Village shop. As the mall grew, great care was taken to keep the historical feel by using reclaimed materials from historic Seattle buildings. Today, Country Village welcomes thousands of visitors to peruse the collection of 45 shops, restaurants, galleries, and antique dealers. Chickens, roosters, ducks, and rabbits share the brick walkways with pedestrians among beautiful plantings, a stream, and a pond. All the shops are privately owned and have a one-of-a-kind feel. Special events, such as the Friday farmers' market, draw people from all over the area.

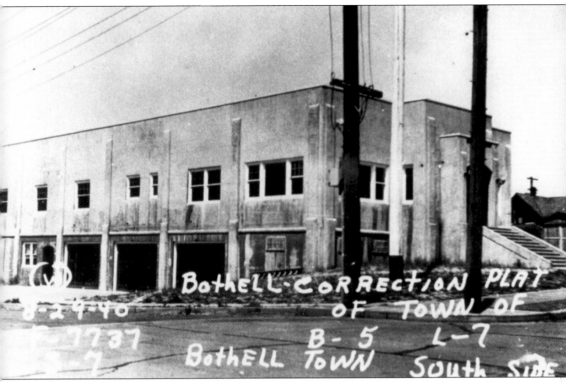

The city hall, built in 1938 as a WPA government project for $35,000, sat on the corner of First and Fir Streets for over 75 years. It was on the same property as the American Hotel, which was built by John Rodgers in 1888. The city hall housed the police department, the fire department, and the public library. On May 12, 1938, a time capsule with a box of records and a cornerstone were placed in the new building. This structure was demolished to make way for the new city hall built in 2015. In the time capsule was a history of the post office, the American Legion Post No. 127, and the Women's Auxiliary written by Almon and Marge Hannan. Other items in the capsule included a 1937–1938 junior and senior high school outline, a Bothell phone book, a Methodist church history, lists of members of various organizations, lists of school employees, and several coins from the 1930s.

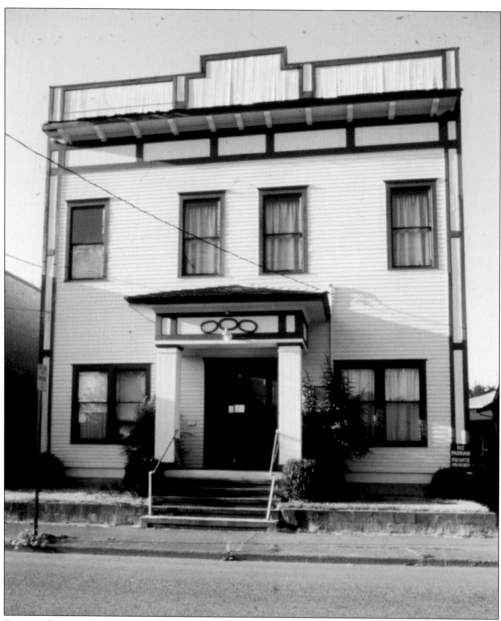

Fraternal organizations were well represented in Bothell. They included the Masons, Knights of Pythias, Macabees, and the Odd Fellows (IOOF). The Odd Fellows Lodge was first fraternal organization established in Bothell. The Odd Fellows symbol shown in this photograph consists of three interlocking oval rings with the letters "F L T," meaning "Friendship, Love, and Truth." When the fire of 1911 destroyed the hall on Main Street, the organization built a new hall on Pine Street (NE 185th Street), which still stands today. The Daughters of Rebekah is the women's branch of the Odd Fellows, and they manage the Odd Fellows Hall in Bothell.

North Creek High School, the newest high school in the Northshore School District, will open in the fall of 2017. North Creek takes its name from the second-largest river/stream in the area. North Creek flows into the Sammamish River, and its valley was known for its premier farmland. After starting with a total of 24 students and 1 teacher in 1885, the public student population in the Northshore district was approaching 22,000 in 2015. This award-winning school district has four high schools, six junior high schools, twenty elementary schools, one alternative high school, and two early learning and network programs. The on-time graduation rate is 93.3 percent. There are 1,189 classroom teachers with an average of 13.5 years' experience, and 95.5 percent of classes are taught by teachers meeting the No Child Left Behind (NCLB) highly qualified (HQ) definition. (Northshore School District.)

Harold "Pop" Keeney coached basketball, baseball, and football for Bothell High School beginning in 1919. He also coached in Anacortes, Sumner, Kennewick, and Longview and was well known for being one of the best high school coaches in the area. According to Bothell football star Bud Ericksen, who went on to play football for the University of Washington, the Bothell team had at least 300 plays, including trick plays. In 1952, at a football game, the Bothell athletic fields were named for Keeney at the halftime show. Keeney died after attending a Friday night football game in 1962. Pop Keeney Field is used by all four high schools, and Friday nights in Bothell in the fall are exciting for kids and adults alike. (Left, Jill Keeney; below, Northshore School District.)

MAY FUNAI — Aspires to be a fashion designer. Motto: "Eat, sleep and be merry today, tomorrow may never come." Cheer Leader 2, 3, 4; Cashier 3, 4; Choir 3, 4; Band 3, 4; Journalism 3, 4; Library 4; Office 4; Junior Prom; Senior Ball; Mothers' Tea 4.

Bothell High School alumni remember the forced relocation of Japanese families, since many Japanese teenagers attended Bothell High School. In 1942, more 110,000 West Coast citizens were displaced and held prisoner for over three years. The above photograph, from the Bothell High School 1940 yearbook, depicts a happy, popular, and talented student, May Funai, who graduated that year. In 1943, an obituary for her mother, Kane Funai, was published on the front page of the *Bothell Citizen*. The Funai family farmed near Hollywood in Woodinville, and it is clear from the article that Mrs. Funai was fondly remembered by her community. According to the daughter of one of May's classmates, the high school students were devastated when their Japanese classmates disappeared in 1942. In 2017, May Funai, age 95, was living in Hawaii with her husband. They own and operate one of the largest fish companies in Honolulu.

Mrs. Kane Funai Dies At Minidoka

Mrs. Kane Funai of Woodinville, passed away in Minidoka Relocation camp of Idaho on April 5.

Mrs. Funai had lived in the state of Washington the past thirty-seven years prior to evacuation. She came from Kumamoto, Japan when seventeen years old. Twenty years she resided in Woodinville, the past two years were spent in Tule Lake, California and Hunt, Idaho, Relacation camps.

She is survived by her husband, Kametaro Funai, five sons, Akila, George, Aubrey, Toshio and Frank. Three daughters, May, Alice Sakura and Lily Uyeda and six grandchildren.

Services were arranged by the War Relocation Authority in Hunt, Idaho, with Crematory services in Salt Lake City. Utah.

The Bothell Landing mall was across the street from the Park at Bothell Landing. Some of the businesses in the mall included the Black Sheep Deli, First Impressions Beauty Salon, McDonald's, Ivars Fish Bar, the Sparrow Christian Bookstore, and the Northshore Citizen. This mall sat on the site of the former Bothell baseball field and was demolished in 2010.

The Park at Bothell Landing, adjacent to the Burke-Gilman and Sammamish River Trails, is a heavily used facility that includes the William A. Hannan House, the Andrew and Augusta Beckstrom log cabin, Bothell's first schoolhouse, and Dr. Elmer Elsworth Lytle's home on display for visitors. The first three buildings are part of the Bothell Historical Museum, and the Lytle home serves as a community center.

The William A. Hannan House was on Main Street between 102nd and 103rd Streets until 1977, when it was moved to the Park at Bothell Landing. Hannan died in 1930, and his wife, Mima, died in 1949. Almon "Dick" Hannan lived in the home until his death in 1954. The house to the west of it was built for Gladys Hannan when she married Ross Worley. Sundance Energy Systems now occupies that structure.

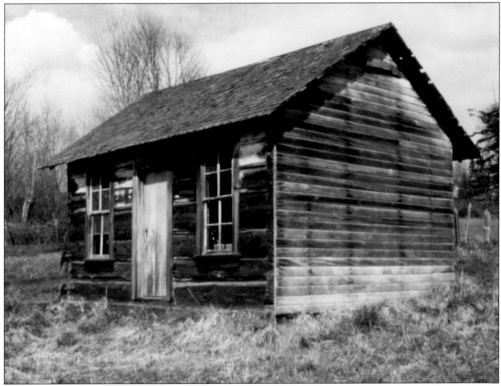

This photograph of the Beckstrom log cabin was taken on the Beckstrom property before the cabin was moved to the Park at Bothell Landing in the 1980s. Andrew and Augusta Beckstrom lived in this cabin in 1884 with their children. It has been preserved in its original state and can be viewed in the park.

Inside Bothell's first schoolhouse in the Park at Bothell Landing, visitors get a taste of what school days were like in early times. For the kids, an activity table is set up with more recent artifacts such as whirly toys, banks, typewriters, and even a rotary phone. (Author's collection.)

Bothell Landing is home to hundreds of ducks and geese. For a time, a large flock of chickens and roosters roamed the area. In the early days, one of the boats that navigated up the river to Bothell was call the *Duck Hunter*; Seattle sportsmen enjoyed hunting expeditions to what seemed like wilderness at the time. (Author's collection.)

On July 22, 2016, a fire broke out in the historic Cooperative Mercantile building site. The owners were in the process of building an apartment complex on the property while maintaining the original brick facade. The fire was so hot that firefighters spent all night protecting the surrounding buildings, including the Norwegian Lutheran church, from the flying embers. (Author's collection.)

The Bothell Mall was built in 1925 and housed a movie theater in the lower level. Most recently, the mall contained the Kozy Korner Restaurant, Rain City Wines, and several other small businesses. The mall was a total loss in the July 2016 fire. (Author's collection.)

On Thursday, July 28, 2016, the Greater Bothell Chamber hosted a fundraising block party and thank-you to the firefighters who traveled from all over to respond to the Cooperative Mercantile fire. Nearly $100,000 was raised to help the 25 different businesses that lost everything in the fire. (Greater Bothell Chamber of Commerce.)

Hundreds attended the fundraising block party on Main Street on July 28, 2016, to hear live music, feast on local delicacies, and enjoy the spirit of community on a warm summer afternoon. The good news is that the Cooperative Mercantile building project is going forward as planned, and the City of Bothell received a $4.7 million grant for a Main Street Enhancement project. (Greater Bothell Chamber of Commerce.)

Bothell has had several slogans throughout the years. In 1909, it was "Bothell the Beautiful." For a time, a duck theme was used, since Bothell Landing and other spots along the river support hundreds of ducks. This flyer for a 1983 race shows the duck theme that did not seem to catch on with locals.

Bothell Chamber of Commerce
and
Univac Track Club

This sign was visible on Bothell Way and could be seen by drivers as they passed by the town. Even those who do not live in Bothell remember the sign, since Bothell Way is a heavily traveled road. Bothell jeweler Richard Olson and a supporting team are partnering with the city to bring back Bothell's iconic welcome sign, which will be located at Bothell Landing, where State Route 527 meets State Route 522. (Richard Olson.)

BIBLIOGRAPHY

Bothell Landmark Preservation Board. *Bothell, Washington Then & Now 1909–2009*. Bothell, WA: Landmark Preservation Board, 2008.

Dover, Harriette Shelton. *Tulalip From My Heart*. Seattle: University of Washington Press, 2013.

Klein, F. & the Northshore History Boosters. *Slough of Memories*. Woodinville, WA: Northshore History Boosters, 1972.

Stickney, A., McDonald, L. *Squak Slough 1870–1920*. Bothell, WA: Friends of the Bothell Library, 1977.

Waterman, T.T. *Puget Sound Geography*. University of Washington Library, Special Collections, 1920.

Woodinville Heritage Society. *Woodinville*. Images of America. Charleston, SC: Arcadia Publishing, 2015.

ABOUT THE BOTHELL
HISTORICAL MUSEUM

The Bothell Historical Museum was established in 1967 and is made up of all-volunteer members dedicated to preserving the history of the town of Bothell and the Northshore area. The museum is located in the Park at Bothell Landing adjacent to the Burke-Gilman/Sammamish River Trail. The 1893 William A. Hannan House has been restored and is furnished with turn-of-the-century items. Bothell's first schoolhouse was a typical one-room school for grades one through eight, and just outside the schoolhouse is the original bell from the first school on the hill. The Beckstrom Log Cabin, the third building in the complex, was built in 1885 and moved to the park in the 1980s. The museum has an extensive collection of photographs, firsthand written and recorded histories, scanned newspapers, and artifacts relating to area pioneers.

Additional information can be found at the following:
Bothell Historical Museum website: www.bothellhistoricalmuseum.org;
Bothell Historical Museum e-mail: bothellmuseum@gmail.com;
Archive of Bothell newspapers: bhm.stparchive.com.

DISCOVER THOUSANDS OF LOCAL HISTORY BOOKS FEATURING MILLIONS OF VINTAGE IMAGES

Arcadia Publishing, the leading local history publisher in the United States, is committed to making history accessible and meaningful through publishing books that celebrate and preserve the heritage of America's people and places.

Find more books like this at
www.arcadiapublishing.com

Search for your hometown history, your old stomping grounds, and even your favorite sports team.

Consistent with our mission to preserve history on a local level, this book was printed in South Carolina on American-made paper and manufactured entirely in the United States. Products carrying the accredited Forest Stewardship Council (FSC) label are printed on 100 percent FSC-certified paper.

MADE IN THE